LEGENDARY LOCALS

OF

GROSSE POINTE

MICHIGAN

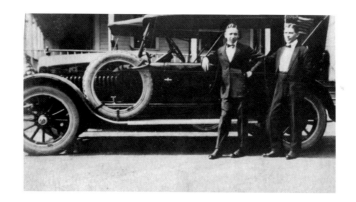

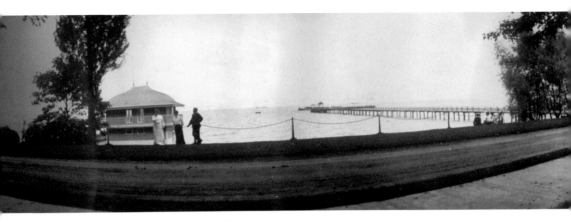

McMillan Boat House and Vista
This long dock was built by Alfred Brush with John Newberry and James McMillan in front of the Lake Terrace property where their cottages stood. Here, they docked their steam yachts *Truant* and *Lillie* (the latter belonged to Brush). The charming boathouse afforded a lovely view of the lake. (Courtesy of the Grosse Pointe Historical Society.)

Page 1: Doerr's Inn
These two gentlemen stand in front of Doerr's Inn. In 1908, Gus Doerr purchased the Neff Hotel and called it Doerr's Inn. He changed the focus of the establishment to attract a younger crowd, bringing in an orchestra with dancing and floor shows. With Doerr's Inn, Grosse Pointe roadhouses became known for lively entertainment. Once Prohibition was enacted, Doerr's Inn was padlocked by the federal government for selling liquor. (Courtesy of the Grosse Pointe Historical Society.)

LEGENDARY LOCALS
—— OF ——

GROSSE POINTE
MICHIGAN

ANN MARIE ALIOTTA AND SUZY BERSCHBACK

LEGENDARY
LOCALS

Legendary Locals is an imprint of Arcadia Publishing
Charleston, South Carolina

Printed in the United States of America

Library of Congress Control Number: 2013935195

For all general information, please contact Arcadia Publishing:
Telephone 843-853-2070
Fax 843-853-0044
E-mail sales@arcadiapublishing.com
For customer service and orders:
Toll-Free 1-888-313-2665

Visit us on the Internet at www.arcadiapublishing.com

Dedication

Ann Marie Aliotta would like to dedicate this book to her aunts and uncles—Rosalie Fazio, Katherine and Royce Richards, and Janet and the late John Henning—with heartfelt gratitude for the legendary support and love they have shown her throughout her life.

Suzy Berschback would like to dedicate this book to her daughters, Charlotte and Madeline, as they begin their careers and share their talents to make a difference to others.

As Grosse Pointer T.P. Hall said more than 100 years ago, "What then is success in life? Is it not to curb the baser promptings of our natures and to give rein to all that is good within us? Is it not to use whatever talents we are endowed with to the best advantage, to delve into the secrets of nature and to overcome obstacles that block the path of human progress, to feel that when we die the world will be something better for our having lived?"

On the Front Cover: Clockwise from top left:
Henry Ford II, grandson of Henry Ford (Courtesy of the Grosse Pointe Historical Society; see page 78), Chet Sampson, school board member (Courtesy of the Grosse Pointe Historical Society; see page 30), Gretchen Carhartt Valade, credited with saving the Detroit Jazz Festival (Courtesy of the Grosse Pointe Historical Society; see page 4), Robert Liggett, owner of the *Grosse Pointe News* (Courtesy of the Grosse Pointe Historical Society; see page 101), Clarence and Betty Pinkston, Olympic diving champions (Courtesy of the Grosse Pointe Historical Society; see page 11), Pierre and Euphemia Provencal, cared for orphans who had lost their parents due to cholera epidemics (Courtesy of the Grosse Pointe Historical Society; see page 37), Anna Thompson Dodge, one of the richest women in the world (Courtesy of the Grosse Pointe Historical Society; see page 106), Eleanor Clay Ford, supporter of the arts (Courtesy of the Grosse Pointe Historical Society; see page 27), Mark Weber, retired president of the Grosse Pointe War Memorial (Courtesy of the Grosse Pointe Historical Society; see page 124).

On the Back Cover: From left to right:
The 2001 Grosse Pointe South High School varsity baseball team, Division I state champions (Courtesy of the Grosse Pointe Historical Society; see page 12), Debbie Reynolds and Eddie Fisher preside over the opening of the new auditorium-gymnasium in 1954 (Courtesy of the Grosse Pointe Historical Society; see page 30).

CONTENTS

ACKNOWLEDGMENTS

We wish to thank the Grosse Pointe Historical Society staff, board, and archives for the photographs used in this book and for their research assistance. We also wish to thank the many people who helped contribute to the making of this book: *Grosse Pointe News*, *Grosse Pointe Today*, *Pointer Magazine*, Don Schulte, Grosse Pointe South archives, Laura McCourt, the Boll family, Little Blue Book Publishing, the Reno family, the Simon family, Wayne State University, *Heritage Magazines*, Elizabeth Carpenter, David Franklin, Grosse Pointe War Memorial archives, John F. Martin Photography, Dana Kaiser, Jackie Kalogerakos, and the many people who have shared their stories with us.

All images within this book were provided courtesy of the Grosse Pointe Historical Society, unless otherwise noted.

INTRODUCTION

Grosse Pointe, Michigan, is one of the oldest communities in the Midwest. Many different types of people from different backgrounds, cultures, and resources have shared the same little bit of land on the banks of Lake St. Clair. Its history is as varied and vibrant as its many inhabitants.

This beautiful piece of land was teeming with game and food when the Chippewa Indians lived a bountiful life along the lake. In the 1600s and 1700s, the French and later British settled along the river, taking advantage of the fertile land for farming and natural shipping ports for trade. Names like Cadillac, LaSalle, and Marquette were among the first Europeans to discover this area.

As Detroit grew and prospered, so did its surroundings, and Grosse Pointe became a popular resort destination. Just a short boat ride up the Detroit River or carriage ride away, the area provided a wonderful day-trip escape from city life.

Soon, wealthy Detroit businessmen and manufacturing tycoons wanted more permanent summer homes in Grosse Pointe. Families including the Fords, Ferrys, Algers, and McMillans all built sumptuous homes along the lake.

They enjoyed the area more and more and after a while, many families wanted to make Grosse Pointe their permanent home. With their wealth came the demand for a certain quality of life.

But the most interesting part of this rich and varied history is the people behind it—the legends in their community, some with national recognition. They give Grosse Pointe its character and spirit. It is these personalities that we hope to explore in this book.

CHAPTER ONE

Arts, Entertainment, and Sports

All work and no play make a community dull, and Grosse Pointe is no dull community. Maybe it is the beautiful environment that inspired creative spirits like actress Julie Harris and writer Jeffrey Eugenides to pursue their artistic passions. Comedian Gilda Radner was first encouraged to perform when attending University Liggett.

Others like singer Anita Baker and architect William Kessler, who moved here, were no doubt stimulated by the supportive environment and creative residents who appreciate and support the arts.

Even counter-culture hero Jack Kerouac found inspiration in Grosse Pointe, where he spent some time with his wife, Grosse Pointer Edie Parker. Some say he penned part of *On the Road* here.

And it must be the lake breezes and fresh air that keeps producing athletes. The community was thrilled when the Grosse Pointe South Baseball team won the state championship in 2001. But long before that, the Pinkstons were making a splash at the Olympics. And who would have thought "little" Prince Fielder would go on to Tigers greatness? Quite a few Grosse Pointe Little League fans, actually.

The artists, performers, and athletes from Grosse Pointe have one thing in common with their business-leader colleagues: though they may have taken a different path to success, they worked as hard and as diligently as their partners in industry.

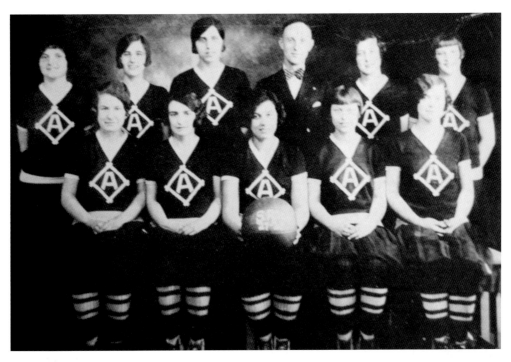

George Elworthy
The first director of the Neighborhood Club was George Elworthy, who headed the club from 1919 until his retirement in 1961. He also coached the St. Ambrose High School girls' basketball team to a state Catholic school championship and an AAU gold medal in 1928. Pictured with him are, from left to right, (first row) Gertrude O'Neill Young, Jane Vanni, Delphine Cocash, Peggy Smith, and Edith Leamon; (second row) Eva Blatz, Agnes Louwers, Helen Watco, Arliss Graef, and Catherine Perry.

George Perles
George Perles is best known in Michigan for leading the 1987 Michigan State Spartan football team to a Rose Bowl victory. But in the 1960s, he coached the Grosse Pointe Park St. Ambrose High School Cavaliers for three seasons, twice winning the Goodfellow Game, which pitted the champion of the Catholic League against the champion of the Detroit Public School League and was considered the biggest football game in the state.

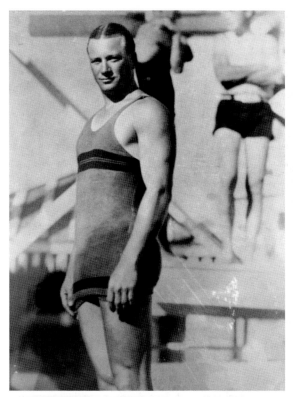

Clarence and Betty Pinkston

Clarence and Betty Pinkston were Olympic diving champions who settled in Grosse Pointe in the late 1920s when Clarence took a job as swimming coach at the Detroit Athletic Club. Clarence was a swimming star from Stanford University. In the 1920 Olympics in Antwerp, he won a gold medal for platform diving and a silver medal for springboard diving. Four years later in Paris, he won bronze medals for springboard and platform diving. But he came home with an ever bigger prize—fiancée Betty Becker. The two had actually met earlier in 1924 at a national championship in California. They courted during the Paris Olympics and married in the US later that year. Betty won a gold medal for springboard diving and a silver for platform diving that summer. She came back in 1928 to win a gold in platform diving in the Amsterdam Olympics, coached by her husband and cheered on by their 18-month-old twins! The couple became a fixture of metro Detroit swimming, with Betty coaching several club teams and helping found the Michigan Inter-Club Swim Association, the prototype of suburban country club leagues in the country.

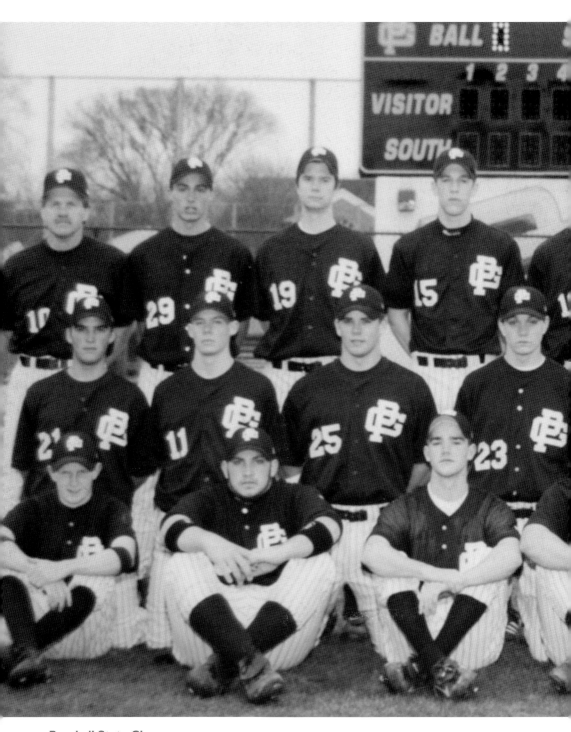

Baseball State Champs
Seen here is the 2001 Grosse Pointe South High School varsity baseball team. For the first time in Grosse Pointe South history, the Blue Devils baseball team won the Division I state championship, edging out Grand Ledge 2–1 before a crowd of almost 3,000 fans at Bailey Park in Battle Creek. It was the first state

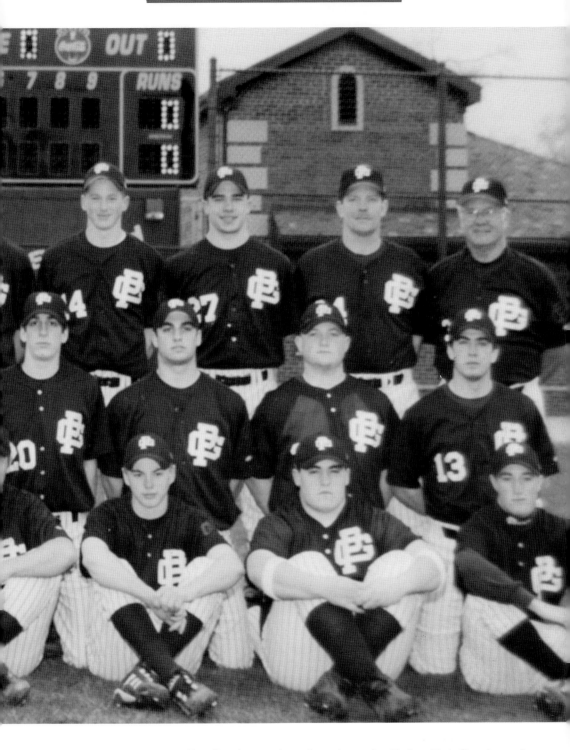

title for the Blue Devils skipper, Dan Griesbaum, who still coaches today. Pitcher Chris Getz (second from left, middle row), who got the save, plays second base for the Kansas City Royals.

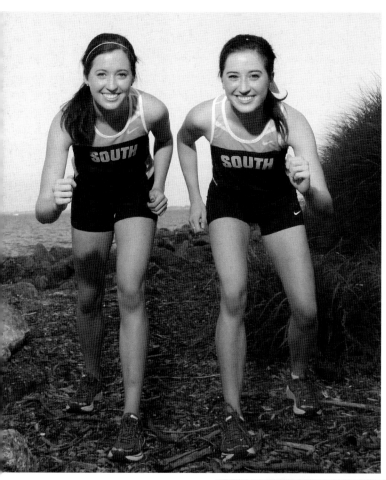

Hannah and Haley Meier
Recent Grosse Pointe South graduates Hannah (left) and Haley Meier might just be two of the most decorated runners in the community's history. Committed to run at Duke University in the fall of 2013, the twins excelled throughout their high school career and led the Blue Devils to win three state track and field team championships in 2011, 2012, and 2013 and a cross country championship in 2011. Hannah, the younger by one minute, was named Michigan's Miss Track and Field for 2013. She and Haley were on the 4-by-800 relay team that set the national high school record in 2012. (Image courtesy of Dana Kaiser.)

Gar Wood
Gar Wood was well known for motorboat racing, setting a new world record speed for a boat—74.870 miles per hour—in 1920 on the Detroit River and winning five straight powerboat Gold Cup races between 1917 and 1921. Thousands of spectators lined Lake Shore Drive to watch him beat the English challenger Kay Don for the prestigious Harmsworth Trophy in 1932. Wood won that trophy nine times. Lover of all things fast, he is seen here in an automobile race down Lake Shore around 1920.

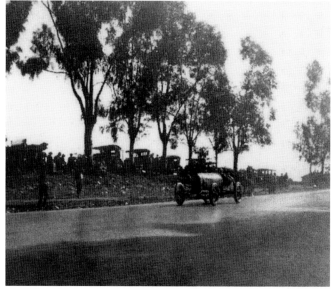

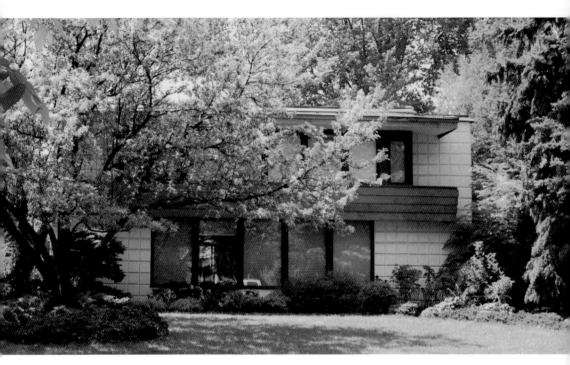

Jeffrey Eugenides
Jeffrey Eugenides was raised on Middlesex in Grosse Pointe Park and attended University Liggett, as well as Brown and Stanford Universities. His first two novels—*The Virgin Suicides*, published in 1993, and *Middlesex*, winner of the Pulitzer Prize in 2003—take place in Grosse Pointe. *Middlesex* was also a finalist for the National Book Critics Circle Award, the IMPAC Dublin Literary Award, and France's Prix Médicis. His most recent book is *The Marriage Plot*. Pictured above is Eugenides's Middlesex home.

Gilda Radner

The hilarious and charming Gilda Radner may have become a star on *Saturday Night Live*, but she discovered her love of theater and entertainment while she was a high school student at Liggett High School (now University Liggett) in Grosse Pointe Woods. The Detroit native later attended the University of Michigan, working at the alternative, student-run radio station WCBN before heading to Toronto where she joined the improv comedy group Second City.

Julie Harris

Called the "First Lady of American Theatre" by no less than the *New York Times*, Julie Harris got her acting start at the Grosse Pointe Country Day School (now University Liggett). Her screen debut was in 1952, repeating her Broadway success in *The Member of the Wedding*, for which she was nominated for an Academy Award for best actress. She starred with James Dean in *East of Eden* and was popular in the role of Lilimae in the nighttime soap opera *Knots Landing*. Along with her Oscar nomination, she has won five Tony Awards, three Emmy Awards, and a Grammy Award.

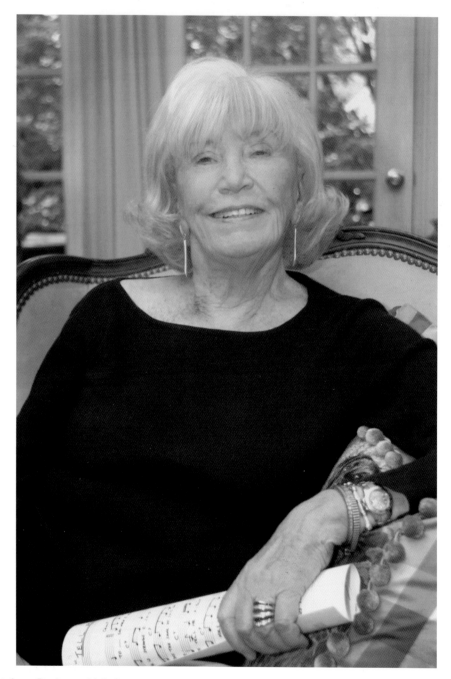

Gretchen Carhartt Valade

Gretchen Carhartt Valade is credited with saving the Detroit Jazz Festival by endowing the music event with $10 million in 2005. The daughter of clothing entrepreneur Hamilton Carhartt, Gretchen's mother was a concert pianist and encouraged her daughter's love of music. Gretchen's passion for jazz also led her to launch the Mack Avenue Records label in the late 1990s and to open the Dirty Dog Jazz Café in Grosse Pointe Farms in 2008. She also owns the Morning Glory Coffee and Pastries and Capricious shoe and accessory boutique.

17

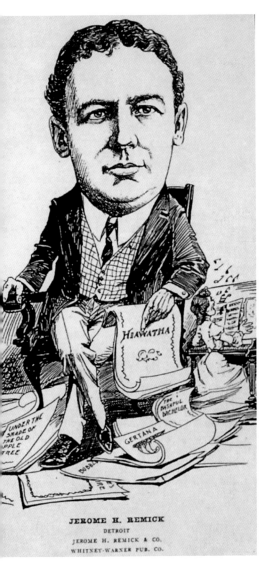

JEROME H. REMICK
DETROIT
JEROME H. REMICK & CO.
WHITNEY-WARNER PUB. CO.

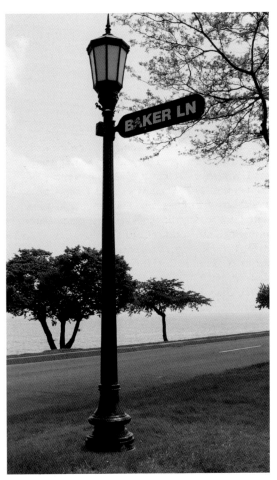

Jerome H. Remick

Jerome H. Remick was the largest publisher of sheet music in the late 19th and early 20th centuries. He pioneered the sheet music store, and across the United States, "Remick Song Shops" allowed patrons to try out the hot Tin Pan Alley hits. George Gershwin, Harry Warren, Al Dubin, Gus Kahn, and Richard Whiting are among the composers and lyricists who worked with Remick. He was also a major supporter of the Detroit Symphony Orchestra (DSO) and his contributions were critical to the construction of Orchestra Hall and the hiring of Ossip Gabrilowitsch as the DSO's conductor.

Anita Baker

Classy and refined, Anita Baker's soulful jazz vocals have made her one of the most popular R&B singers of recent times. Her major-label debut album, 1986's *Rapture*, went platinum and won two Grammys, containing the two hits "Caught Up in the Rapture" and "Sweet Love." She has since produced numerous hits and is one of the music business's most revered singer-songwriters. She lived in Grosse Pointe Farms on Baker Lane, a subdivision developed by her then-husband, Walter Bridgeworth.

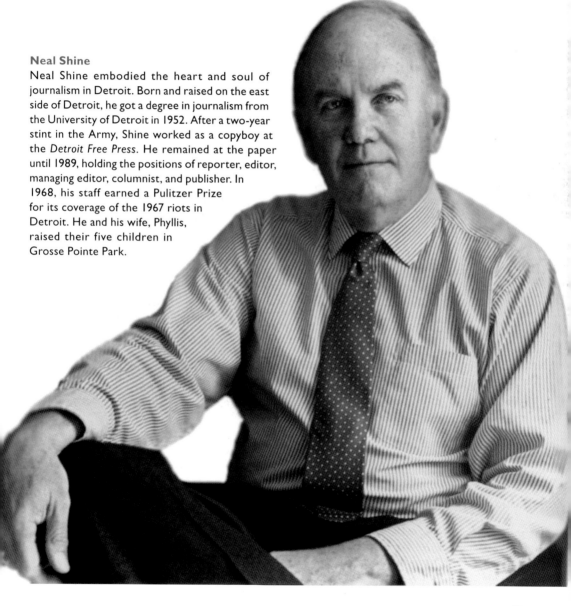

Neal Shine

Neal Shine embodied the heart and soul of journalism in Detroit. Born and raised on the east side of Detroit, he got a degree in journalism from the University of Detroit in 1952. After a two-year stint in the Army, Shine worked as a copyboy at the *Detroit Free Press*. He remained at the paper until 1989, holding the positions of reporter, editor, managing editor, columnist, and publisher. In 1968, his staff earned a Pulitzer Prize for its coverage of the 1967 riots in Detroit. He and his wife, Phyllis, raised their five children in Grosse Pointe Park.

John Hughes

Adolescent impresario John Hughes spent his early childhood in Grosse Pointe before moving when he was 12 to the North Shore of Chicago, the setting of his signature movies. He was the voice of 1980s teenaged angst for a certain set (upper-middle-class suburbanites), who found their stories and sorrows eloquently told in films like *Sixteen Candles, The Breakfast Club,* and *Ferris Bueller's Day Off.* He reached a wide audience with other movies like *Planes, Trains and Automobiles, Uncle Buck,* and *Home Alone I, II,* and *III.* Before he broke into movies, the college drop-out (he attended Arizona State for two years) worked as a writer at the Leo Burnett ad agency and at *National Lampoon* magazine.

Edgar Louis Yaeger

Edgar Louis Yaeger was a modernist painter from Detroit who was commissioned by President Roosevelt's Works Progress Administration (WPA) to paint three murals for Cleminson Hall at the Grosse Pointe High School (now Grosse Pointe South). The commission, part of the program to bring art to public buildings, was considered a top honor. The murals, completed in 1939, depict various symbols and people associated with education. Yaeger returned to the school in 1990 at age 86 to sign the work, which he had never done, and to repair one of the panels that had been damaged when it was improperly cleaned.

Charity Suczek
When Charity Suczek died at 98 in 1997, she was known throughout the Pointes and beyond for her expertise on fine food and the art of living. Born in Vienna to an officer in the Austrian Imperial Army and a prominent socialite, she learned the lifestyle of the aristocracy early. She traveled extensively as a young woman and moved to Grosse Pointe in 1928 with her husband, a successful inventor and engineer. A great patron of music, she was involved in the early years of the Grosse Pointe War Memorial Summer Music Festival, the Detroit Symphony Orchestra, and the Detroit Institute of Art's Pro Musica Series. She became well-known for her gourmet cooking classes, teaching and lecturing throughout metro Detroit, Michigan, and the United States as Madame Charity.

Josephine Alger

The cover of a 1909 *Colliers* magazine featured an illustration of a young woman on an airplane commissioned by publisher Robert Collier, a friend of Russell Alger who knew the stories of Russell's daring daughter Josephine. No doubt that same Josephine and the magazine cover also inspired Tin Pan Alley songwriters Fred Fisher and Alfred Bryan to compose "Come Josephine in my Flying Machine." According to Alger family letters, the song was written about Josephine Alger's early flight experiences in Grosse Pointe. The song was made famous again in the 1997 blockbuster movie *Titanic*.

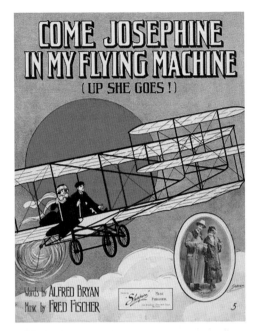

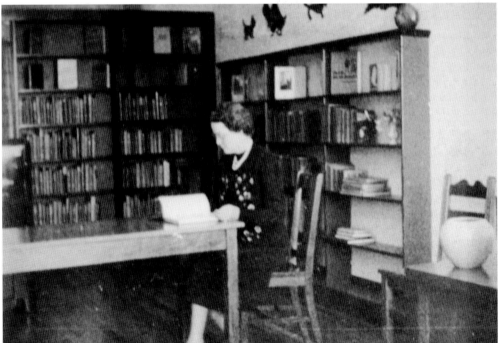

Florence Severs

The Wayne County Library organized a station in the Grosse Pointe Shores Village Hall in 1922, but soon, Grosse Pointe felt it needed a bigger, stand-alone library. In 1928, a separate branch building was opened and Florence Severs was appointed branch librarian. She had more than 3,000 books in the library, with many children's and reference books. Her philosophy was, "If books are made accessible, they will be read."

Coureurs de Bois

Long before this area was discovered and settled, Grosse Pointe's first entrepreneurs, the bold, French adventurers called Coureurs de Bois, or "runners of the woods," had pitched their tents on the shores of Lake St. Clair. They learned the ways of the woods from the Native Americans and became expert trappers, hunters, traders, and explorers. They often traveled by canoes, which the Indians taught them how to make out of silver birch bark.

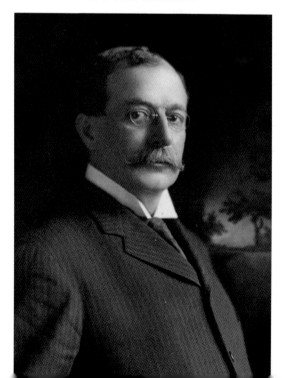

Frank Woodman Eddy

The first president of the Detroit Athletic Club, Frank Woodman Eddy was a college athlete who was reportedly disappointed with the sporting opportunity Detroit offered when he moved here to start his business career in 1875. He found success as a business and civic leader with a particular emphasis on athletic endeavors. He helped with the DAC's reorganization, was a charter member of the Detroit Boat Club and belonged to the Country Club, the Yontodega Club, the Grosse Pointe Hunt Club, and the Big Point and Caledon Mountain Clubs of Ontario.

23

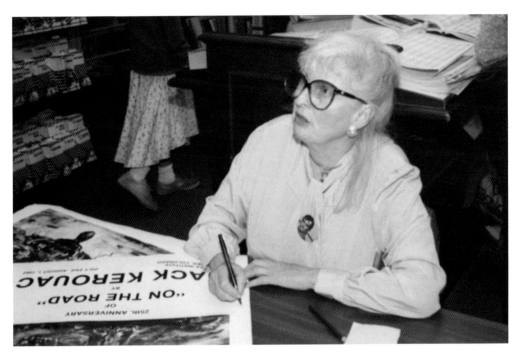

Edie Parker and Jack Kerouac
Edie Parker (above) was an 18-year-old socialite from Grosse Pointe when she met Jack Kerouac (below) at Columbia University in 1940. They moved in together and became friends with some of the leading voices of the Beat Generation—William S. Burroughs and Allen Ginsberg among others. Jack spent time with Edie and her family in Grosse Pointe and there is even a legend that he wrote part of *On The Road* at Rustic Cabins in Grosse Pointe Park. The two married in 1944, supposedly so Edie could receive an inheritance and bail Jack out of jail (he was charged as an accessory in a murder case). Within a few years, their union was annulled. The character Judie Smith in Kerouac's novel *The Town and the City* is based on Edie. Her memoir *You'll Be Okay* was published in 2007.

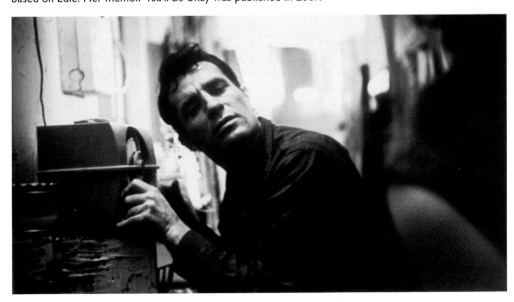

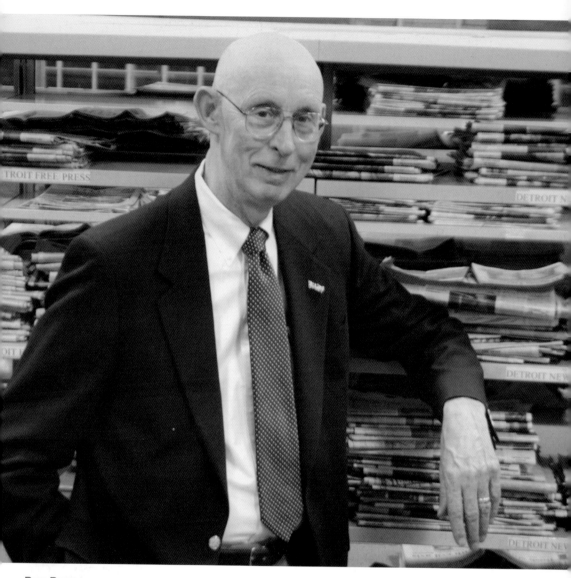

Ben Burns
Most recently known for his dedication to the journalism program at Wayne State University, Ben Burns had a long and distinguished career as a journalist, starting as a cub reporter for the United Press International news agency. His 30 years in the business included stints as executive editor of the *Detroit News*, editor and publisher of the *Macomb Daily* and the *Daily Tribune* in Royal Oak, and numerous awards and accolades. He also ventured into online journalism, cofounding grossepointetoday.com.

Garden Club of Michigan
The Garden Club of Michigan was founded in Grosse Pointe in 1911. Many prominent Grosse Pointe women were officers including Mrs. Benjamin S. Warren, Mrs. John S. Newberry, Jessie S. Hendrie, Mrs. Edward H. Parker, Mrs. John M. Dwyer, Mrs. Edwin S. Barbour, Sarah W. Hendrie, Mrs. Dexter M. Ferry, Mrs. Fred T. Murphy, and Mrs. Frederick E. Ford. The club's first public activities were tulip and daffodil shows. When the Garden Club of America was founded in 1913, the Garden Club of Michigan became a charter member, taking part in its National Program of Education and Legislation, war work (the Land Army and Food Production), conservation, and highway improvement. The group was instrumental in preparing a planting plan in 1933 for the Lake Shore Road in Grosse Pointe Farms, resulting in three miles of flowering trees along Lake St. Clair.

Eleanor Clay Ford

One of the great matriarchs of the Ford dynasty, Eleanor Lowthian Clay was teaching the Fox Trot in the very refined atmosphere of Annie Ward Foster's dancing school when she met Edsel Ford, the only child of Henry Ford. The two married in 1916 and began their family, building a gracious, Cotswold-styled home on Gaukler Pointe in Grosse Pointe Shores where they raised their four children, Henry II, Benson, Josephine, and William. Eleanor, who was the niece of Joseph L. Hudson, founder of the famed Detroit department store, was a great philanthropist and champion of the arts and culture. She bequeathed her magnificent home to a trust to be used for the benefit of the public. Today, the estate is open for guided tours and hosts numerous cultural events throughout the year. Below, Eleanor is pictured at the far left in the top image and second from the left in the bottom image.

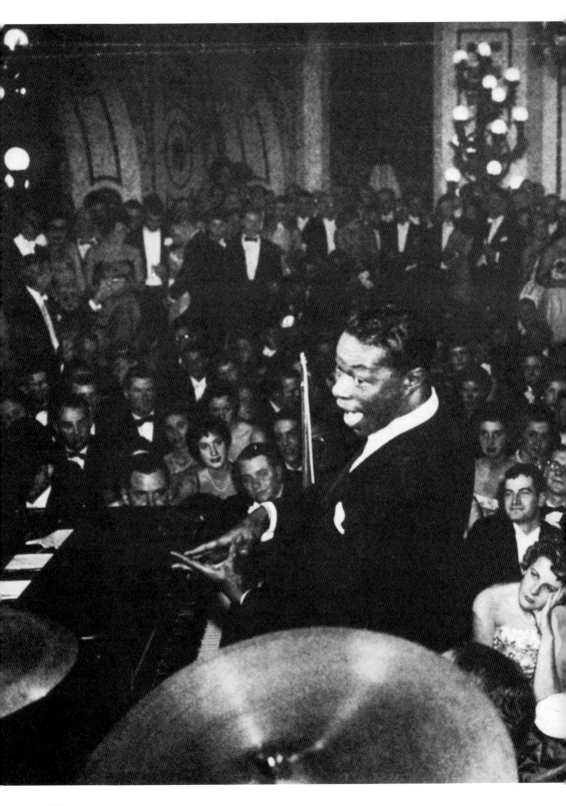

Charlotte Ford and Nat "King" Cole
When Charlotte Ford entered society in 1959, her parents, Anne and Henry Ford II, threw her a lavish debutante ball at the Country Club of Detroit in Grosse Pointe Farms. The guest list topped 1,200 and included Roosevelts, du Ponts, Firestones, and a Churchill. It reportedly cost $250,000—$60,000 for flowers alone, which included two million magnolia leaves flown up from Mississippi that covered the walls of a corridor leading to the reception room which was decorated with blooming trees and hedges to look like a formal garden. The entertainer of the evening was Nat King Cole whom Charlotte picked personally. He performed for half an hour in the main ballroom and sang a song he wrote just for her.

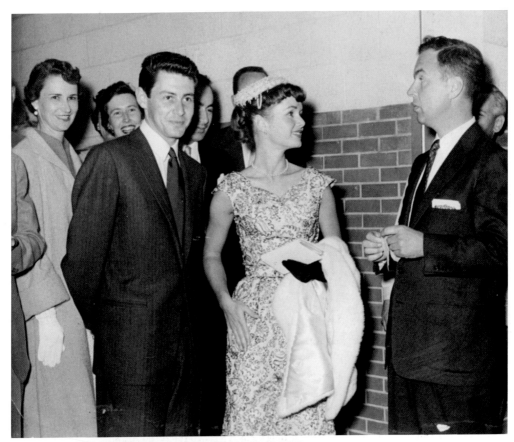

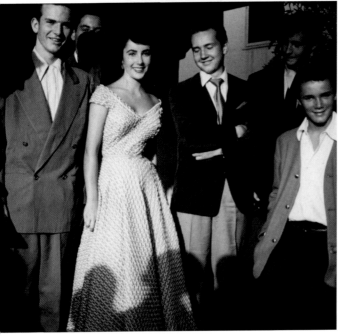

Debbie Reynolds and Eddie Fisher Former math and science teacher and school board member Chet Sampson organized cross-country camping tours in the 1940s and 1950s, shepherding thousands of Grosse Pointe teens over the years to national parks in the Southwest and California, including stops in Los Angeles. He became acquainted with such Hollywood notables as Elizabeth Taylor, Ronald Reagan, Cary Grant, and Bob Hope. He even convinced Debbie Reynolds and Eddie Fisher to come to Grosse Pointe to preside over the opening of the new auditorium-gymnasium at Grosse Pointe High School in 1954. Pictured above are Eddie Fisher (left), Debbie Reynolds, and Chet Sampson. At left, Elizabeth Taylor is surrounded by Grosse Pointe High School students.

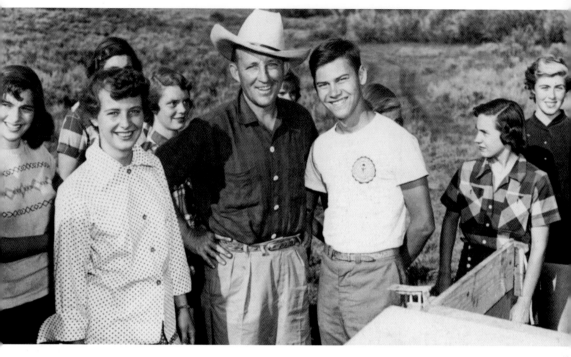

Chet Sampson

Teacher Chet Sampson's trips included a caravan with as many as 11 station wagons and 2 cooking trailers with compartments for food, ice boxes, and two Coleman stoves with ovens. Students camped at night, then went to Hollywood during the day where they visited movie sets and met some of the stars, including Cary Grant, who is pictured in the center of the first row in the photograph below. A highlight of the trip was camping overnight at Bing Crosby's ranch (pictured above).

Prince Fielder
Detroit Tigers fans get a thrill each time first baseman Prince Fielder steps up to the plate. But local fans got the same thrill years earlier when Prince played for the Grosse Pointe Woods-Shores Little League. The story goes that when he was nine years old, he was already hitting them out of the park—Ghesquiere Park, that is. He lived in the community when his father, Cecil, played for the Tigers. Prince is pictured standing in the center of the third row.

Gloria Whelan

Gloria Whelan is the author of novels, short stories, plays, and poetry. In 2000, she won the National Book Award for Young People's Literature for the novel *Homeless Bird*. Other honors include an O'Henry Award, several Pushcart Prize nominations, Michigan Author of the Year, and American Library Association awards. She worked for many years as a social worker, and it wasn't until she was 54 that her first book, *A Clearing in the Forest*, was published by Putman, in 1978. Her latest work, a novella and series of stories called *Living Together*, was published in the spring of 2013. She lives in Grosse Pointe Woods.

Mary Mannering Wadsworth

Mary Mannering was a beautiful young actress in England when she was "discovered" by producer-manager David Frohman, better known for building the Lyceum Theatre, Broadway's oldest theater. He brought her to the US, where she became a great success. While on tour in Detroit, she met Frederick E. Wadsworth, a Detroit capitalist and boat manufacturer. They married in 1911 and took up residence in Wadsworth's Grosse Pointe Farms estate, which became the scene of many social activities until it burned to the ground in 1916. At that time, there was a popular philanthropic movement to provide decent housing for working men and their families, which became a passion of Mary's. In 1912–1913, she planned and had erected 32 cement block cottages for working men's families in the city of Grosse Pointe. They were built on property owned by her husband and cost about $1,500 to build. They helped satisfy the great need that existed at that time in Grosse Pointe for better homes for the working classes. Generous-sized lots were used, many being 250 feet in depth, allowing for ample garden and play space. The cottages were identical: 28 feet by 42 feet in size with six rooms and a bath. They were built on posts and had no basement. Stove heat was used, a common method of heating during this period. The cottages rented for $25 per month. About 12 are still standing; one is at the corner of St. Clair and Waterloo Streets and was once used as the Public Library of the City of Grosse Pointe. Mary and Frederick E. Wadsworth are pictured above.

CHAPTER TWO

Heroes, Legends, and Namesakes

What does it mean to be a legend? In a community like Grosse Pointe, the answer is multi-faceted.

Since the community's roots go back to the 1600s, tall tales and myths are as plentiful as the waves of Lake St. Clair on the shore. The first French settlers brought stories of ghosts and goblins to their new homes. These stories helped explain the unexplainable and comfort the settlers in their strange, new land. Legends like the loup garou, La Lutin, and the Devil's Grist would entertain and also caution the "habitants," whose lives in the new land could sometimes be dangerous.

Along with ghosts, Grosse Pointe has many flesh-and-blood legends. Civic-minded and conscientious, generation after generation of residents signed up to serve in the armed forces, putting their lives on the line to protect our freedom. As early as the Civil War, Grosse Pointers took up arms to defend the country they loved. In every battle since, brave young men and women went off to war, leaving their proud families behind to keep vigil.

Taking a drive or a stroll through Grosse Pointe, one will realize the street names themselves read like a litany of Grosse Pointe legends—icons who have left their mark on the community either by their contributions to commerce and civic causes or by the property they owned and how those properties shaped and impacted their surroundings. Names like Rivard, Cadieux, and Allard are just directional to today's residents, but at one time they had much deeper meanings. They represented working farms, large families, and founders of the community.

Fr. Louis Hennepin
On August 12, 1679, the Feast of St. Claire, Robert Cavelier, Sieur de La Salle, and his party sailed a double mast ship called *Le Griffon* (pictured below) up the straits of Detroit to a lake called Otsiketa, "for sugar or salt," by the Huron Indians. The ship's chaplain, Louis Hennepin (pictured at left), a Franciscan priest and cartographer, christened the water Lac Sainte Claire, to commemorate the day and honor the saint.

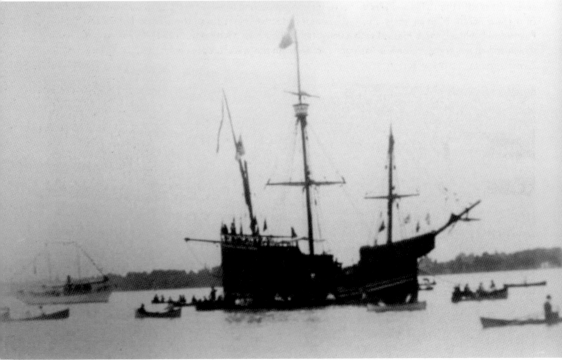

Pierre and Euphemia Provencal

Pierre Bourgeat Provencal, a blacksmith from Detroit, decided to trade in his hammer and anvil and go into the country to try farming in the early 1800s. He bought land on the shore of Lake St. Clair, cleared the trees, and built a home. In 1831, at the age of 36, Pierre took a wife, Euphemia St. Aubin, whose great-great-grandfather had arrived in Detroit with Antoine de la Mothe Cadillac. The two were married by Fr. Gabriel Richard in St. Anne's Church. For many years, the couple had no children of their own but shared their growing wealth with the less fortunate children of the area. Over the next 20 years or so, the Provencals took in a number of orphans who had lost their parents due to the cholera epidemics that swept the area in the 1830s and 1840s. Pierre set up a school and hired teachers for these youngsters. Each of these children, 24 in all, grew up and became productive members of the Grosse Pointe community. Pierre and Euphemia were blessed with a daughter of their own, Catherine, in 1845. She lived in the home which still stands today, though it has been moved from the water's edge and is the headquarters of the Grosse Pointe Historical Society.

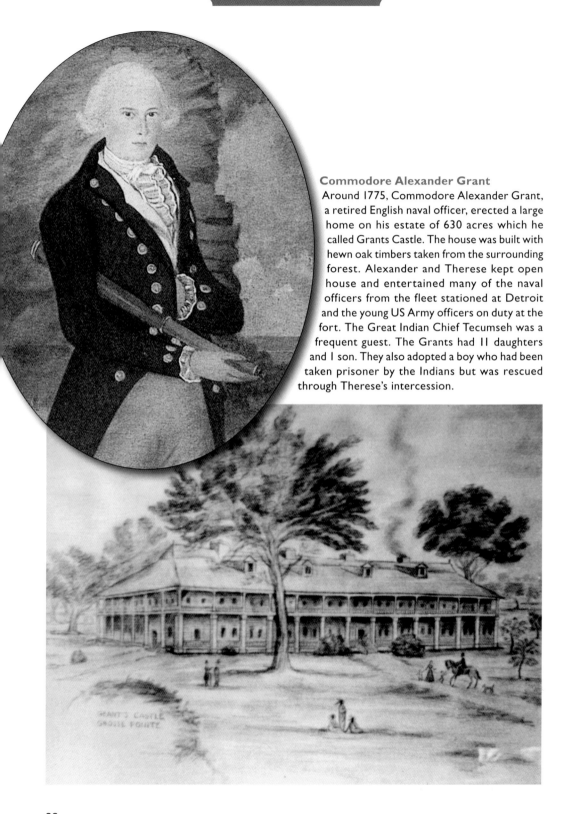

Commodore Alexander Grant

Around 1775, Commodore Alexander Grant, a retired English naval officer, erected a large home on his estate of 630 acres which he called Grants Castle. The house was built with hewn oak timbers taken from the surrounding forest. Alexander and Therese kept open house and entertained many of the naval officers from the fleet stationed at Detroit and the young US Army officers on duty at the fort. The Great Indian Chief Tecumseh was a frequent guest. The Grants had 11 daughters and 1 son. They also adopted a boy who had been taken prisoner by the Indians but was rescued through Therese's intercession.

Jane Richards

Plymouth, England, natives Jane Richards Quick and her husband, Frederick, a plasterer by trade, had been living in Detroit for about two years with their daughters Phyllis May and Winifred Vera when Jane and the girls went back across the pond to visit relatives in 1912. They returned a short time later, aboard the *Titanic*. The three were placed in lifeboat No. 11 and were rescued. Jane remained in America the rest of her life, raising her family on Roslyn Road in Grosse Pointe Woods. For many years, she traveled the country reliving her experiences to avid theater audiences. Jane died at age 86 on February 24, 1965, at Bon Secours Hospital.

Marie Caroline Watson Hamlin

Marie Caroline Watson Hamlin was a frequent guest of the Halls at their lakeside home, Tonnancour, where she and her cousins would spend hours listening to the weird legends and superstitions devoutly believed and told by old French habitants. A poet and writer herself, Marie was entranced with these

stories and gathered them together in her 1883 book, *Legends of Le Detroit*. The book's dedication reads, "To the Loved Ones at 'Tonnancour' on the banks of Lake St. Clair, where Under the Grateful Shade of a Majestic Willow I have listened to Many a Tale of the Mystic Past, These Legends are Most Affectionately Dedicated."

Loup Garou

Many years ago at Grosse Pointe, a French Canadian trapper named Simonet settled on the lake shore. His young wife had died in the early years of their marriage, but she had left a little baby, Archange. Archange grew to be a beautiful young woman and Pierre La Fontaine, a young farmer, fell in love with her. Soon the two were engaged. One evening before their wedding, Archange heard a rustling sound outside and, looking up, saw a monster with a wolf's head and an enormous tail, walking erect as a human being. Simonet comforted his daughter, but silently feared the monster was the dreaded loup garou or werewolf. The day of the wedding dawned and a great celebration took place in the couple's new home, built for them by Simonet. While the merry-making was at its height, the dreaded loup garou rushed into their midst, seized Archange, and escaped with her into the forest. Pierre ran after them, followed by all the men, but their search was fruitless. About a year later, at his sister's wedding, Pierre rushed into the woods as if in pursuit of something. He returned chasing the loup garou to the very edge of the lake. The loup garou, seeing no escape, stood on one of the boulders strewn along the shore and stretched out his arms as if summoning some mysterious being. A large fish was seen to rise on the surface of the water and opening its mouth, the loup garou vanished. The footprint of the wolf can still be found in Grosse Pointe forevermore on one of the boulders on the lake shore.

Goblin Horseman Le Lutin

French Habitant Jacques L'Esperance, or Jaco, as he was called, was not much of a farmer, but he was an expert horseman. He could be seen every day driving his favorite horse, L'Eclair (lightning), along the lake shore. One morning at the stable, he found his beautiful mare covered in burs, her mane tangled, tired and weary as if she had been ridden all night. It happened again and again so he put a lock on the barn door. The next morning, he found her in the same state, with no evidence that anyone had broken into the barn. His fellow Habitants told him of the dreaded goblin which had been haunting the Pointes, Le Lutin. Le Lutin hated the Habitants and taunted them by riding their best horses at night, but Jaco was not convinced. He sat at his window that night with his rifle to catch whoever the culprit was. Watching the barn door, he saw his beloved L'Eclair fly out; on her back was a fearful vision. He knew his rifle was powerless against such a villain. He threw holy water on the monster, which screamed and then drove the horse into the chilly waters of Lake St. Clair, never to be seen again. After that, Jaco marked all his horses with a cross, fearing the return of Le Lutin.

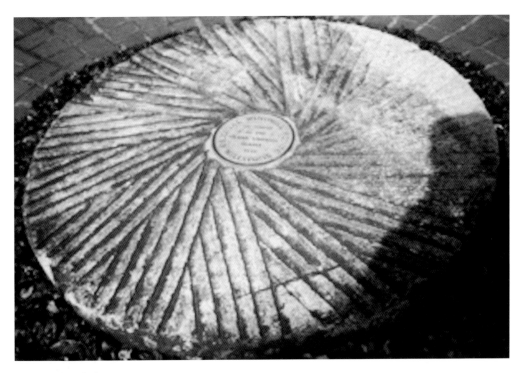

The Devil's Grist

Many tales have been told about the early French settlers of old Grosse Pointe and one of the most popular is that of the stone gristmill built on the tip of land extending out into Lake St. Clair, known today as Windmill Pointe. The story goes that it was built in the early 1700s by a Frenchman called Jean Le Duc, who came to the area with his sister, Josette. In the same spot several years earlier was a horrible massacre of the Fox tribe. Some say more than 1,000 were killed and that the ground was haunted, but Jean was not deterred. He built the mill, which was owned in part by Josette. One day, Josette became quite ill. Her brother attended to her conscientiously but one day delicately asked to whom she would leave her share of the mill. Infuriated by his question, Josette replied that not one of her family members would inherit her share, that she would leave it to the devil. Josette did recover, but was found dead in her bed some months later. That same night, a furious storm arose. Waves crashed against the shore and the wind howled. Thunder clapped and a bolt of lightning shook the point and the old stone mill was split in two. A fiendish laugh was heard above the raging storm—the devil had come to claim his bequest. For years afterward, when a northeast storm blew from the lake, it was said a hideous figure could be seen trying to repair the mill and grind the devil's grist. One millstone from this windmill is now located in the Trial Gardens at the Grosse Pointe War Memorial, pictured above. The other has never been found.

Fox Indians

When Antoine de la Mothe Cadillac established Detroit in 1701, he built Fort Pontchartrain, which was envied by the English since it was the key to entering the Upper Great Lakes region. Hoping for an alliance with the English, the Fox Indians attacked Fort Pontchartrain in Detroit in 1712. More and more of the Fox attacked the fort until Huron, Pottawatomie, and Ottawa warriors came to the aid of their French allies. Their savage war whoops shattered the silence of the forests, and terrified the anxious hearts inside the surrounded fort. Branches of the Sacs, Illinois, and even Osages and Missouri tribes, also hurried to aid the fort because they were natural-born enemies of the Fox and Macoutin tribes. The Fox Indians were driven back and took shelter at Presque Isle, the entrance of Lake St. Clair, now known as Windmill Pointe. For days, they held their stronghold, and 1,000 Fox Indians fell beneath the weapons of the attackers. The English allies carried away their dead and wounded, but left the remains of the conquered to the mercy of the elements. Shortly afterward, the last remnants of the Fox nation came to Presque Isle to "hold the feast of the dead" and to cover the bones of their warriors. Until the late 1800s, their bones were exposed by the ruthless plow, and anyone interested in Indian relics would have found some on this hallowed ground.

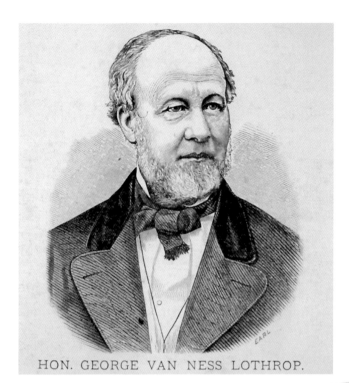

HON. GEORGE VAN NESS LOTHROP.

George Van Ness Lothrop
George Van Ness Lothrop was so impressed with the beauty of Grosse Pointe when he moved to Detroit in 1850 that he bought 130 acres and built a summer home, Summerside. Lothrop was a prominent lawyer and later American Minister to Russia. Summerside had the first private tennis court in Grosse Pointe.

Drs. William and Joseph Belanger
In 1941, William George Belanger was doing his residency in radiology at Harper Hospital after interning there and earning degrees from Wayne State University and the Detroit College of Medicine, when Pearl Harbor was attacked. He enlisted as a radiologist with the 17th General Hospital of Detroit and served overseas for two years. Long before that, Belanger attended the old Cadieux Elementary School and was in the third class to graduate from the new Grosse Pointe High School in 1931. His father, Joseph Alfred Belanger, was a well-known surgeon in Grosse Pointe. His mother, Louise, was a pharmacist who established the Grosse Pointe Pharmacy on Jefferson Avenue in 1907.

The Poupard Family

The Poupard family farm was one of the most prosperous in the Grosse Pointes, presided over by Simon and Genevieve in the mid-1800s. It occupied the parcel of land near today's Yorkshire and Bishop Roads in Grosse Pointe Park. Simon was one of the organizers of the first volunteer fire department in the area, which indicated high social standing. Charles A. Poupard is a descendant of this family. He served as treasurer for the board of education for 31 years, reportedly never missed a meeting, and was known for his kindness. Poupard Elementary School opened in 1951. Unfortunately, Charles died before he could be honored at the opening of the school. Genevieve is pictured above with one of the farm horses.

The Kerby Family

John Kerby Sr. bought a parcel of land from his father-in-law in 1796 for £120. He and his wife, Alice, built the wooden house pictured above and opened a dirt lane to Mack Avenue that became known as Kerby Road. Rufus Kerby, grandson of Alice and John Sr., lived in this house with his wife, Catherine Van Antwerp. Rufus was the village's first postmaster and ran a post office and small general store from the home in the late 1800s. In 1893, Rufus sold the lakefront portion of his tract and moved his house inland on Kerby Road near Charlevoix Street, not far from the Kerby family cemetery. In 1912, the house was sold to his cousin E.J. Tucker. In 1928, he sold the acreage to the school system as the site for the "new" Kerby School. In the 1940s, the house was again moved to 310 Kerby Road—its present location.

The Rivard Family

The Rivard family was among the early French settlers in the Grosse Pointe area. The first Rivard to come to this country was Nicolas Rivard dit Lavigne, who was born in 1624 in France and was married in 1652. Francois Rivard was at Fort Pontchartrain in the year 1713. On October 30 of that year, he was a witness for one of the first weddings at the fort. Michael Rivard was born on December 17, 1846, in Mount Clemens, Michigan. Michael was the son of John Baptist Rivard and Matilda Robert Jeanne. He married Virginia Godfroy, who was born on February 28, 1852, in Mount Clemens. Michael and Virginia were married in Grosse Pointe. The Rivard farm was one of the largest in Grosse Pointe. In 1900, Paul Rivard build a road house called the Castle House on the property. Descendants of the Rivards continue to live in Grosse Pointe today, though all that's left of their ancestors' farms are subdivisions that follow the original property lines and streets that bear the family's name. Paul Rivard is pictured below.

The Reno Family

In the spring of 1946, the daughters of Laurence J. Reno, Judith (left) and Roberta, stand in the front yard of their home at 312 Reno Lane. Behind them, running along the iron fence, is the dirt lane in front of the original Kerby School. Note the playground equipment and cement area adjacent to the back of school. Reno is the Anglicized form of Renaud/Reneau, the French family that came to Grosse Pointe in the late 1700s. Louis Reno was granted Private Claim 223 in 1808. Descendants of his owned the property that is now Reno Lane and lived there until 1991.

Cadieux Clan

In 1803, at the age of 18, Frenchman Michael Cadieux came to the Detroit area, joining other family members. In 1835, he bought land in Grosse Pointe in the area of today's Cadieux Road. He had an extensive farm on the property and sold trees for lumber. He raised his family of 12 children with his wife, Archange. His son Isadore built a white clapboard farmhouse that is still standing today. Francis Cadieux served as the District No. 1 School Inspector for 33 years. (District No. 1 was a predecessor to today's Grosse Pointe Public School System). One of the district's first school buildings was named the Cadieux School after the Cadieux family. Pictured at right is infant Isadore Cadieux; below are Michael Cadieux and members of his family.

William McInnes and Lawrence of Arabia

Many Grosse Pointers know the story of Lawrence of Arabia, but how many know that one of their neighbors actually rode with him across the Assyrian desert? William McInnes was born in Lanarkshire, Scotland, in 1894 and immigrated to Grosse Pointe in the late 1920s when he found work as a gardener at the newly built Paul Deming estate at 111 Lake Shore Drive. His horticultural duties must have seemed a bit tame, however, compared to his previous military service. In 1912, just shy of his 18th birthday, McInnes enlisted in the British Expeditionary Forces. He was sent to the Middle East at the start of World War I, where he served in the Battle of Galopoli and the Salonika campaign. He then moved on to Cairo, Egypt, where he was assigned as the quartermaster for T.E. Lawrence, who came to be known as Lawrence of Arabia. Sergeant McInnes told of being part of a group of soldiers who crossed the desert on camels with the equivalent of $250,000 in gold to give to the Arabs; none of the soldiers knew which of them had the gold. He is named as a 10-pound Talbot gunner in Lawrence's book, *Seven Pillars of Wisdom*. McInnes became a US citizen in 1935. His two daughters graduated from the newly built Grosse Pointe High School in 1939 and 1941. Throughout the 1930s and 1940s, he was an active participant in Grosse Pointe and Eastern Michigan Horticultural Society's annual Flowers, Fruit and Vegetable Show, and he helped plan and care for two Victory Gardens in the area. With his soft Scottish accent, McInnes was a favored golfing guest of Dr. Frank Fitt, the head minister of Grosse Pointe Memorial Church. Golf, gardens, and war stories were shared on a regular basis with the popular Presbyterian cleric. He and his wife bought a house on Chalmers Street in Detroit where they lived for six years, returning to Grosse Pointe in 1947 to live at the Deming Estate until he died in 1960. Members of the Grosse Pointe and Eastern Michigan Horticultural Society are pictured here, with William McInnes crouching second from the right in the first row.

Alan Marschke

In 2009, Alan Marschke contacted the Champion Tree Project, a program that clones heritage trees, preserving historic trees through new technology. These magnificent French pear trees of Grosse Pointe and the vicinity are found nowhere else in America. The origin of these famous old trees is obscure. The prevailing opinion is that the trees came from seeds brought from France, then were tended to lovingly by the Jesuit missionaries. Hence, they are sometimes called "the Mission Pears." A number of these pear trees can still be found in Grosse Pointe, including three giant pear trees, possibly more than 200 years old, near the corner of Lake Shore Drive and Oxford Road.

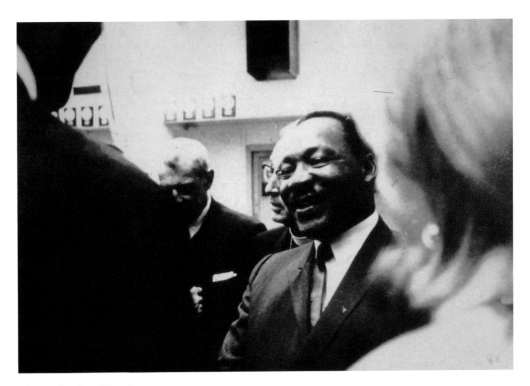

Martin Luther King Jr.
On March 14, 1968, three weeks before his assassination, Martin Luther King Jr. was in Grosse Pointe (pictured above) speaking to a receptive, standing-room-only crowd in the high school gym on issues of social injustice and tolerance in America. He was invited to speak by the Grosse Pointe Human Relations Council, a group of concerned citizens who worked on issues including fair housing. This situation was so volatile, according to accounts in the society's files, the Grosse Pointe Farms police chief actually sat on King's lap in the car ride to the high school in order to protect him.

Evangeline Lodge Land Lindbergh

Evangeline Lodge Land Lindbergh was a relative of the Berry and Lodge families. Her father was Dr. Charles Land, a dentist and inventor. After graduating from the University of Michigan, she taught chemistry at Cass Tech High School, then taught high-school science in Little Falls, Minnesota, when she met C.A. Lindbergh Sr., who became a US senator. Their aviator son Charles (pictured here) was born in 1902 in Detroit, where Evangeline's family lived. She eventually returned home and lived in Grosse Pointe.

"Soapy" Williams

Six-term Michigan governor G. Mennen "Soapy" Williams was raised in the conservative confines of Grosse Pointe society, attending Princeton and the University of Michigan Law School, but he became one of the most well-known Democrats in the state. Heir to the Mennen soap fortune (hence his nickname), Williams was never dressed without his trademark bow tie. He also served as chief justice of the Michigan Supreme Court. The Mackinac Bridge was built during his time as governor.

Walter R. Cleminson
Grosse Pointe High School (now Grosse Pointe South) grew tremendously under the leadership of principal Walter R. Cleminson, who took the helm in 1940. Cleminson, originally from Marquette, Michigan, led the development of the industrial arts building and the auditorium-gymnasium, as well as program expansion including creative writing classes and an honors curriculum. The beloved administrator died in a car accident in 1957, to the shock of the community. Cleminson Hall was named in his honor.

Frank Charbonneau
Serving in the US Armed Forces was all in the family for Frank Charbonneau. Born in Grosse Pointe in 1922, he was called for active duty in the Army in 1943 as a member of the Student-Enlisted Reserve Corps at the University of Detroit. He was part of Gen. George S. Patton's Third US Army, XII Army Corps, 71st Fighting Division, fighting in France and Germany, and he was awarded a Purple Heart and a Bronze Star. His father, Louis, was an officer in World War I and was recommissioned at the start of World War II. His brother Louis Jr. was in World War II in the US Air Force.

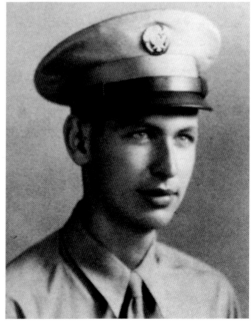

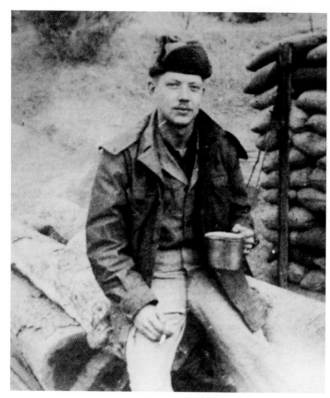

Wesley T. Barr
Just 19 when he enlisted in the Marine Corps, Wesley T. Barr was on the front lines calling in fire as a forward artillery observer. Like his fellow servicemen, he dealt with extreme weather conditions including 90-degree summers and winter temperatures well below zero. Barr was 24 years old when he returned home.

Donald Reid
With two years of college under his belt, Donald Reid left the ivory tower to pursue his passion and attend flight school. He later joined the US Air Force and was sent to Korea, starting out as a wingman in a squadron fighting fire bombers, but later achieving his goal of becoming a fighter pilot. Attaining the rank of colonel, Reid later became a commander of the air defense group at Selfridge Air National Guard Base in Harrison Township, Michigan.

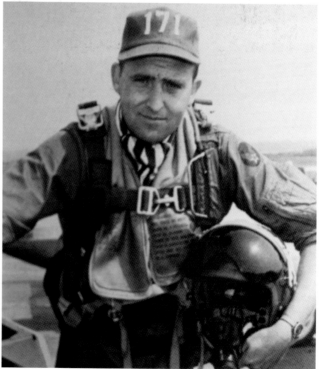

John R. Dykema,
John R. Dykema interrupted his law school education at the University of Michigan in 1941 and volunteered for the US Navy. He fought in the Battle of Midway and later made what is believed to be the deepest recorded dive by a submarine at the time—more than 500 feet— after a Japanese airplane tried to bomb the vessel and missed. After V-J Day, he returned to law school and went on to become a partner in the firm of Dykema, Gossett, Spencer, Goodnow & Trigg.

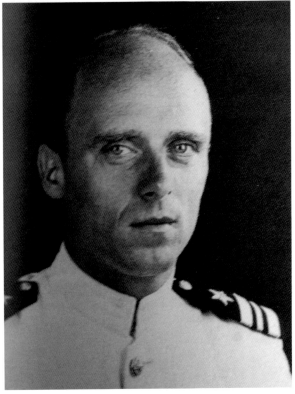

Frederic Sibley
A former Eagle Scout, Frederic Sibley joined the US Navy and joined a naval squadron in the Aleutian Islands in 1942. Its goal was to seek out enemy fleets, report them to their superiors and conduct bombing raids if possible. Attaining the rank of lieutenant commander, he was first reassigned to Chicago to conduct carrier training on Lake Michigan, and later to a naval air station in Daytona Beach.

Grosse Pointer's Great Escape

When William Newnan was drafted into the US Army infantry in 1942, he could hardly have imagined his tour would include breaking out of a German prison camp near Florence, Italy. Newnan escaped by crawling through a hole in the prison fence, then returned to the Allied forces with the help of the Italian farmers he met along the way. His adventures inspired him to write a book, *Escape in Italy*, which was published by the University of Michigan Press in 1945.

Earl Heenan Jr.

A member of the Reserve Officer Training Corps at Princeton University, Earl Heenan was commissioned as a lieutenant by the US Army when he graduated in 1941 and was sent to the China-Burma-India theater. He went into combat as a liaison officer with the Chinese 75-millimeter Howitzer artillery batteries, advising the Chinese on how to fight against the Japanese. He was awarded the Silver Star.

Gerard Bufalini

Gerard Bufalini published a powerful poem titled "Baptism by Fire" in the October 1985 issue of *Heritage* magazine, expressing emotion about his experience in Vietnam. Here is an excerpt: "as the firing died away… / I came upon a soldier / lying bloody in the grass / more steel than flesh / …i / thought how / fragile / insignificant / my life had suddenly become i / reloaded / my rifle / felt / for my grenades and / steeled / my mind / against death."

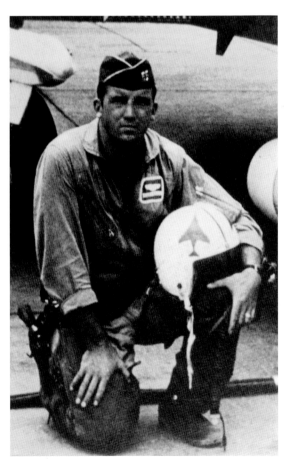

Thomas R. MacDougall

Thomas R. MacDougall entered the US Air Force in 1961, after graduating from the University of Buffalo, which he attended on an athletic scholarship. He had two tours of duty in Vietnam and was awarded numerous medals of honor for his courage including the Silver Star, six Distinguished Flying Crosses, the Bronze Star, and two Purple Hearts. He was shot down on a beach in South Vietnam on Memorial Day 1976 and almost lost his right arm, but he recovered from his injuries after numerous surgeries at Wright-Patterson Air Force Base in Dayton, Ohio.

Frank J. Sladen Jr.

A well-known teacher and beloved community leader, Frank J. Sladen Jr. lost a leg in a land mine explosion in Germany during World War II. He taught at Detroit University School, Grosse Pointe Country Day School, and, in 1964, was named headmaster of University Liggett Academy.

He and his wife, Betty, ran a small bookstore, The Book Shelf, for nearly 15 years. A dedicated Rotarian, he also served on the board of the Grosse Pointe War Memorial for an unprecedented six terms.

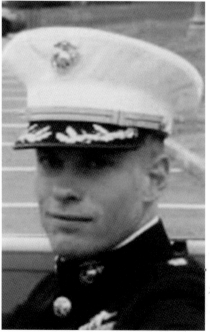

Maj. Joseph T. McCloud

Maj. Joseph Trane McCloud, of Grosse Pointe Park, was a 17-year US Marine veteran. He was killed in Iraq on December 4, 2006—10 days shy of his 40th birthday—when the CH-46 helicopter he was in crashed into a lake in the Al Anbar province near Baghdad. The married father of three graduated from Grosse Pointe South High School where he played football. He was assigned to the 2nd Battalion, 3rd Marine Regiment, 3rd Marine Division, III Marine Expeditionary Force, in Kaneohe Bay, Hawaii.

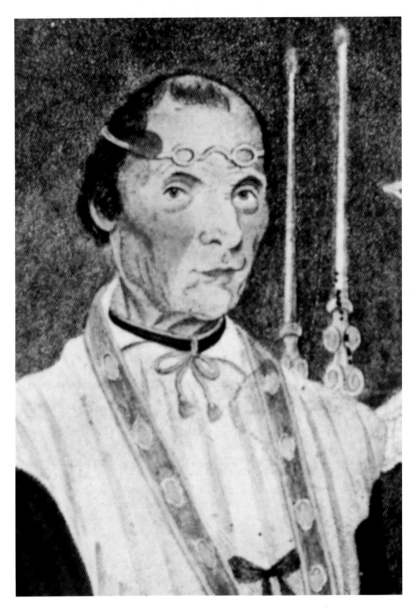

Fr. Gabriel Richard

Born in La Ville de Saintes, France, Fr. Gabriel Richard came to Detroit in 1798 to be the assistant pastor at St. Anne's Church. Part of his duties were as a circuit rider, or visiting priest, and he made regular trips to Grosse Pointe, often leading mass at the home of Pierre Provencal. He established a school in the town near the church and another at the Grand Marais, near present-day Water Works Park, where many French squatters lived in little shanties on the islands of solid ground which dotted the great marshy track on the river front of Grosse Pointe Township. In the summer months, the pupils were brought to and from the school in small boats by their relatives. In the winter months when the marsh was frozen over, the pupils were able to walk. Many of the older ones enjoyed skating to school on the ice surrounding the solid islands in the marsh. Father Richard was a cofounder of the University of Michigan and served as vice president and trustee. He also was a delegate from the Michigan Territory to the US House of Representatives. He has a school named after him in Grosse Pointe Farms.

CHAPTER THREE

Business and Community Leaders

Grosse Pointe has thrived and flourished since settlers first stepped onto its shores, due in large part to the entrepreneurial spirit, business acumen, and sense of responsibility that characterize many generations of residents.

The first titans of industry in Grosse Pointe didn't have corner offices or boardrooms. The legendary Coureur de Bois, those scrappy French trappers and traders, made their living off land using ingenuity and initiative as the key ingredients for success.

These ingredients would carry over for generations to come. Farmers realized the rich, fertile soil and easy access to fresh water were ideal conditions for agricultural success. With their relentless hard work and persistence, the farms thrived and grew.

Perhaps inevitably, manufacturing and commerce began to replace agrarian pursuits, and as Detroit's fortunes rose, so did Grosse Pointe's. Many of Detroit's business leaders came to Grosse Pointe for recreation and leisure. Leaders like James McMillan, Theodore Hinchman, and T.P. Hall were among those who wanted to take their families away from the hustle and bustle of Detroit and out to the country for a summer respite. Their "cottages" were magnificent to say the least, but only a handful remain; they were eventually torn down to make way for the next group of business kingpins. Thankfully, these buildings have been captured in photographs and illustrations.

Industrialists like the Dodges and Fords, however, decided they wanted the Grosse Pointe lifestyle year-round and they built palatial permanent residences along the lake. They threw lavish parties, bought expensive toys, and some lived lives of excess, if not happiness.

Though the community may be known for its wealth, the back story is one of generosity and charity. Countless community members, like the Algers, Sales, and Joys, and more recently, families like the Cottons and Bolls, have given their time, talents, and resources to help those less fortunate and share the gifts they've been given. Some helped create institutions like the Neighborhood Club and Full Circle. Others, like the Provencals and Morans, opened their homes to impoverished children in the area to help them recuperate from serious illness.

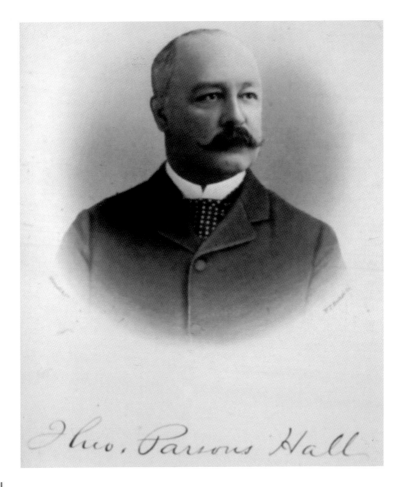

T.P. Hall

Theodore Parsons Hall was born in 1835 into a family whose ancestors were among the original colonists in Connecticut. He graduated from Yale University and moved to Detroit to open a bank with the brokerage firm Thompson Brothers. Here he met Alexandrine Louise Godfroy, who had quite a pedigree. A descendant of one of the oldest families in Normandy, France, and one of the founders of Detroit, she was named for Gen. Alexander Macomb, a relative. Alexandrine was born in Springwells and was educated for a time at the new boarding school built by the Religious of the Sacred Heart. In 1880, the couple built their dream home, an elegant Victorian chalet, on a beautiful 63-acre plot along Lake St. Clair. They named it Tonnancour after a title and "seigneurie," or estate, in the Godfroy family in French Canada. Originally built as the family's summer home, here they entertained their large family and had frequent visitors. Marie Caroline Watson Hamlin, a cousin and author of *Legends of Le Detroit*, spent much time at Tonnancour and set a number of her tales near there. A successful businessman, T.P. Hall had numerous cultural pursuits including literature, publishing, agriculture, and travel. He insisted his children receive excellent educations and augmented their studies with extensive family travels to important historical and cultural sites. A member of the Detroit Young Men's Society and the Detroit Club, Hall was affectionately called the "Sage of Tonnancour." He and Alexandrine were gracious hosts and Tonnancour was a social hub of the area. They built a boathouse where they held dancing parties, billiard games, and dramatic productions in the theater. Many notable Grosse Pointe families, including the Newberrys, McMillans, Joys, Hendries, Brushes, Lothrops, Morans, and many others were frequent guests. Connected to the boathouse by a narrow pier was a grotto where Alexandrine, a devout Catholic, spent many hours in prayer.

William Kessler

A graduate of the Harvard Graduate School of Design, where he studied with Bauhaus master Walter Gropius, William Kessler moved to Grosse Pointe to work as chief designer for Leinweber, Yamasaki and Hellmuth, architects. A fellow of the American Insitute of Architects, Kessler received numerous awards including the gold medal in 1974 and 1976, the Hastings Award in 1984 and the Charles A. Blessing Award in 1996. He designed the Kresge-Ford Building at the College of Creative Studies.

Jane Fisher and Fisher's Road House

Fisher's House was one of the most famous of the many road houses that operated in the township during and after the Civil War. During the early 1850s, Merritt M. Fisher purchased the old Hudson property, then a part of the Ten Eyck farm in Grosse Pointe Farms, and built a new establishment on the property at the foot of Fisher's Lane, now Fisher Road. Fisher discovered a clay deposit about a half mile away, and there, he constructed a brick kiln and supplied the contractors with the necessary brick that was used in the construction of his tavern. The hotel was three stories high with a frontage and depth of about 100 feet. The full-front veranda must have given the hotel an outstanding reputation in the country. Inside were 10 large guest rooms in addition to the family and servants' quarters. Here, frog-leg dinners were served to thousands of Detroiters who made the journey especially to partake in the delicious meals for which Fisher's House had become famous. The Grosse Pointe Democratic Club made the building its headquarters for many years. After Fisher's death in 1861, his wife, Jane, operated the establishment for some time, then leased it, and finally sold it in 1886 for $16,000 to a group of prominent Grosse Pointe citizens who organized the Grosse Pointe Club. They erected a new clubhouse on the property that same year. The name was later changed to the Country Club. This property was later purchased by Horace Dodge's widow, Anna, and her new husband, Hugh Dillman. They razed the clubhouse and built their lavish home, Rose Terrace II.

VanDamme's Half Way House
In the first few decades of the 20th century, Grosse Pointe was home to numerous roadhouses known for good food, festive libations, and lively entertainment. VanDamme's Half Way House, on the corner of Mack and St. Clair Avenues, was built by Levin VanDamme and was known as one of the best spots for gambling in the Pointes. Levin ran the first establishment from 1909 to 1920, then retired and leased the building to "Kid" Harris. A story goes that a man was killed there over a gambling dispute during Harris's last days in 1923. The place remained vacant for five years until it was sold to Johnny Ryan, who turned it into one of the most well-known gambling resorts in Wayne County. He employed a number of privately owned cars for which he paid drivers $15 for an eight-hour shift to pick up would-be gamblers from a rendezvous at Woodward Avenue and Elizabeth Court and bring them out to the resort. He also had men known as "cappers" who daily contacted sporting enthusiasts at clubs, hotels, and speakeasies to invite them to the resort.

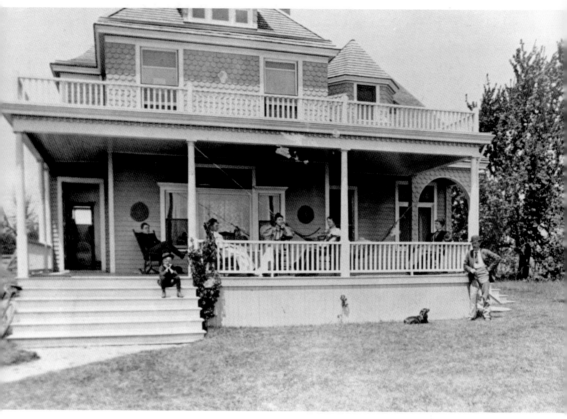

Mary A. Moran

During the cholera epidemic of 1854, Mary A. Moran, wife of Richard R. Moran, brought many children from poor, stricken families into her home and treated them with a natural remedy made from Native American herbs, along with supplying medicine to their parents in Detroit. The fresh air and clean water at the Moran home helped tremendously, too. As soon as the parents were able to care again for their children, they were returned to them and another group of children was taken in. Above, Mary is pictured third from the left.

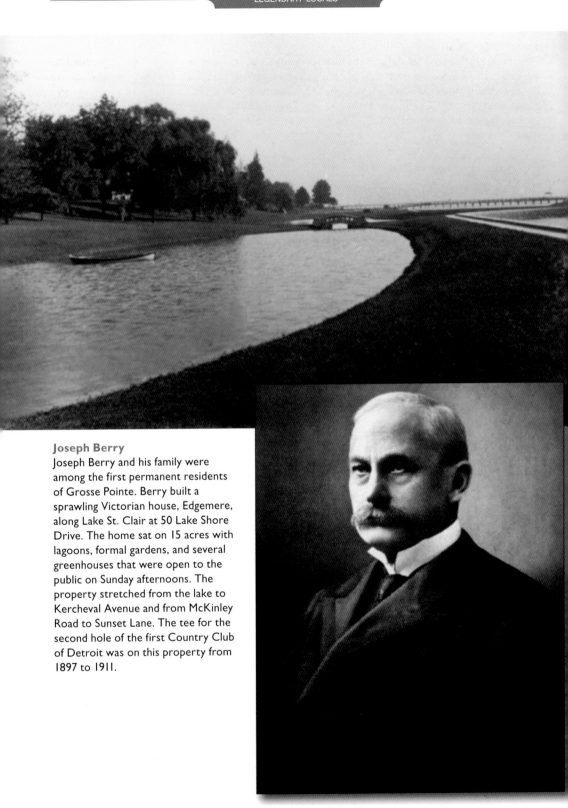

Joseph Berry

Joseph Berry and his family were among the first permanent residents of Grosse Pointe. Berry built a sprawling Victorian house, Edgemere, along Lake St. Clair at 50 Lake Shore Drive. The home sat on 15 acres with lagoons, formal gardens, and several greenhouses that were open to the public on Sunday afternoons. The property stretched from the lake to Kercheval Avenue and from McKinley Road to Sunset Lane. The tee for the second hole of the first Country Club of Detroit was on this property from 1897 to 1911.

Edmund A. Brush

Edmund A. Brush and his family had been summer residents of Grosse Pointe in the mid-1800s when they decided to move to the community permanently. Edmund, his wife Eliza Cass Hunt, and their five children lived in a home called the Pines, which was set back several hundred feet from the lake and hidden by a group of evergreens. He had accompanied General Cass, his wife's uncle, on his famous canoe expedition for the exploration of the upper lakes. When he returned, he worked at a number of prominent municipal offices and helped secure the construction of several of the railways leading into Detroit.

Strathearn Hendrie

Strathearn Hendrie was the oldest son of George and Sarah Sibley Trowbridge Hendrie. George, a native of Scotland, was a railroad executive, who helped to bring interurban trolleys to Grosse Pointe. Strathearn married Catharine Marie Moran and they raised William Van Dyke, George Strathearn, and Elizabeth Trowbridge in a beautiful home on Lake Shore Drive in Grosse Pointe Farms, where Strathearn was a trustee. He became a railroad director himself and also served in the Spanish-American War. Strathearn and Catharine are pictured with (from left to right) George, William, and Elizabeth.

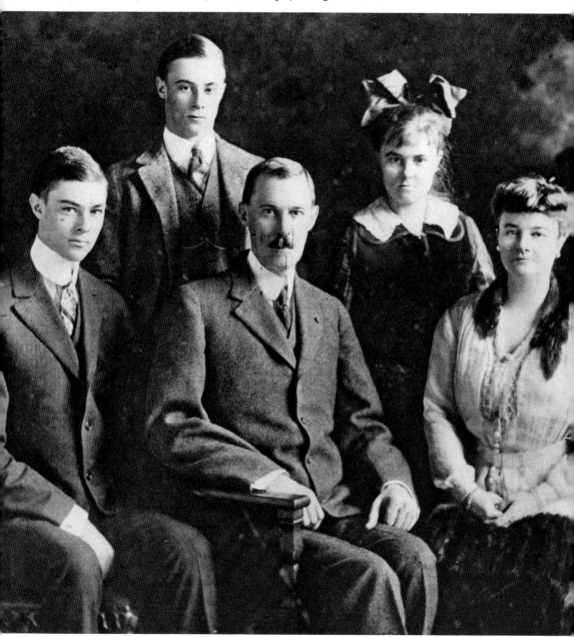

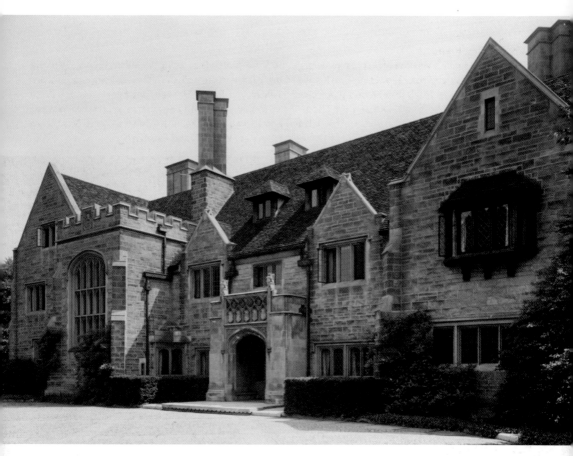

Standish Backus
Standish Backus is most well known for his leadership of the Burroughs Adding Machine Company, but few know he helped fund the 1920 Near East archeological expedition of University of Michigan professor Francis Kelsey, for whom the Kelsey Museum in Ann Arbor is named. Backus, a University of Michigan alumnus, married Lotta Boyer and raised five children in this gracious home on Lake Shore Road. He was secretary of General Motors Corp. before joining Burroughs.

John Wynne Jr.
John Wynne
Jr. built this Queen
Anne–style summer
home on the lake
in 1896. He was
a well-known and
respected Detroit
attorney whose
client, Theodore P.
Hall, gave him his
property to build
upon. His home
is still standing
today, one of the few
remaining Victorians
from that era in
Grosse Pointe.

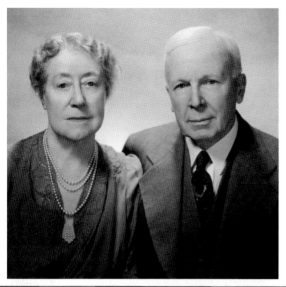

Edgar and Anna Scripps Whitcomb

Edgar Bancroft Whitcomb was a successful businessman who married Anna Scripps, the daughter of *Detroit News* founder James Edmund Scripps. Edgar and Anna were great benefactors of the arts, especially the Detroit Institute of Arts. Anna was a passionate gardener who cultivated hundreds of rare and exotic orchids in the greenhouses on her estate, which she shared with the public at the annual Detroit Flower Show. When she died, hundreds of her treasured orchids were donated to the Belle Isle Conservatory, which was then renamed in her honor. Below, Edgar (left) and Anna (right) are pictured with Eleanor Clay Ford.

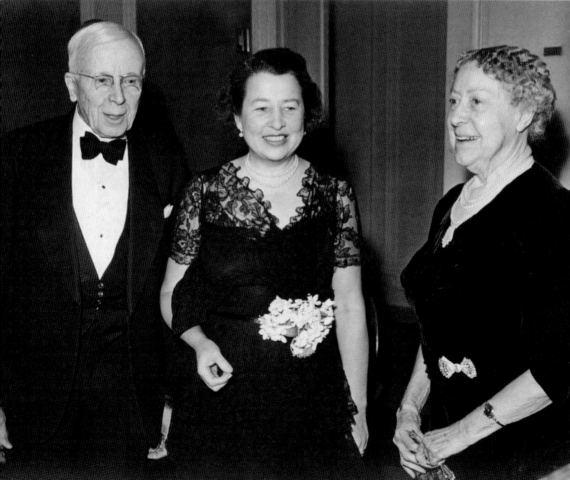

Leonard B. Willeke
One of the most gifted and prolific architects to work in the Grosse Pointes, Leonard Willeke designed homes, commercial buildings, landscapes, and even furniture. The longtime Grosse Pointe Park resident was most well-known for the Oscar Webber residence in Grosse Pointe Shores, the Raymond Purdy house in Grosse Pointe Park, the Hupp Motor Car factory in Detroit, and the Fordson Village Development commissioned by Henry Ford. He was known for his fastidious attention to detail and favored intricate brickwork. Mrs. Leonard B. Willeke is pictured here with her husband.

Edsel Ford (OPPOSITE PAGE)
The only child of Henry Ford, Edsel was destined to enter the automobile industry. He was more interested in the styling of the cars than the mechanics of them, and he played a major role in developing the Lincoln and Mercury lines, including the luxury Lincoln Continental. In 1989, at the age of 22, he became company secretary and three years later was named president, a post he held until his untimely death at the age of 49. His relationship with his father was close, but it was also fraught with challenges. He was a devoted husband to Eleanor and father to their four children they raised in Grosse Pointe Shores. The Edsel and Eleanor Ford Estate is now open to the public for tours and events.

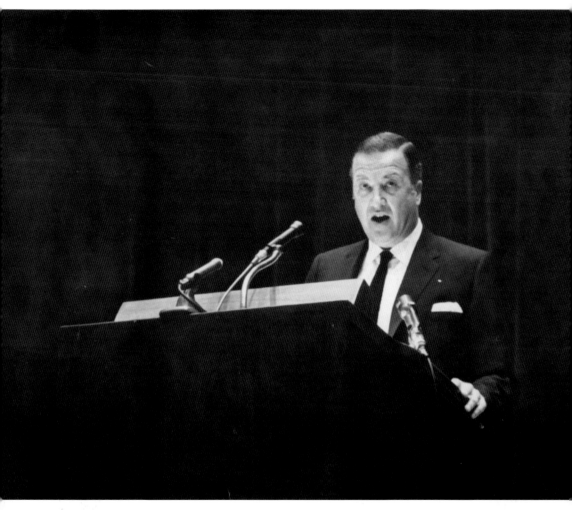

Henry Ford II
A grandson of Henry Ford, "Hank the Deuce," as he came to be known, is credited with turning around the failing company when he took over in the mid-1940s. The son of Edsel and Eleanor Clay Ford, Henry Ford II was raised in the luxury his grandfather eschewed and enjoyed the comforts and indulgences that wealth could bring.

Henry Ledyard

Henry B. Ledyard was president of the Michigan Central Railroad in 1882 when he decided to build his home on a lovely 50-acre plot of land called Cloverleigh. The home was built on a high ridge with a graceful slope of lawn going down toward the lake. A rustic log boathouse was built on the lakefront. Ledyard was a descendant of one of Detroit's first mayors and his mother, Matilda, was the daughter of Gen. Lewis Cass. He was born in Paris while his father was a diplomat there. Under his leadership, the railroad grew and prospered. He was also interested in community service and was at one time president of the board of trustees of the Grosse Pointe Memorial Church when it was known as the "Ivy-Covered Church."

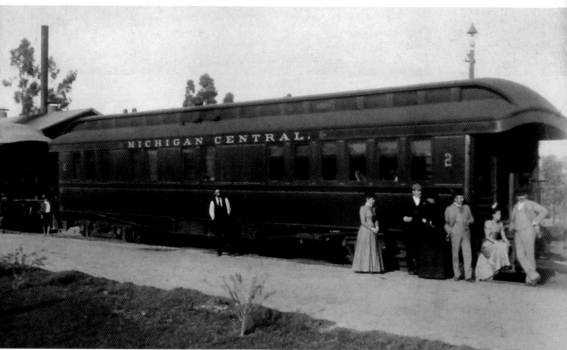

Chief Justice Dorothy Comstock Riley
Born in Detroit where she attended public schools, Dorothy Comstock Riley received her law degree from Wayne State University in 1949, one of just three women in her class. While living in Grosse Pointe, she was the first woman appointed to the Michigan Court of Appeals, and later became the first woman appointed to the Michigan Supreme Court, later elected chief justice. This remarkable jurist served as a very active role model and was very involved in organizations including National Women Judges Association, Michigan Women's Campaign Fund, the National Women Lawyers Association, and the Michigan Supreme Court Historical Society, which she founded. She was inducted into the Michigan Women's Hall of Fame in 1991.

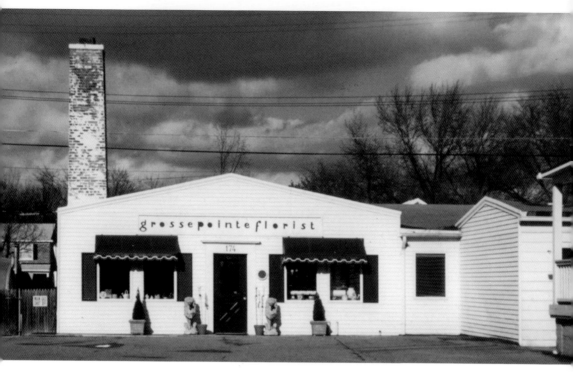

Farquhars and Grosse Pointe Florist

In the 1920s, some of the gardeners of the grand estates opened up their own florist shops. One of these was the Grosse Pointe Florist at 174 Kerby Road. This charming florist, now nestled in a residential neighborhood, has been providing flowers and plants to the community since then. It has been run by generations of the Farquhar family, who have been very involved in the community in other ways. Current owner Jim Farquhar is also the mayor of Grosse Pointe Farms.

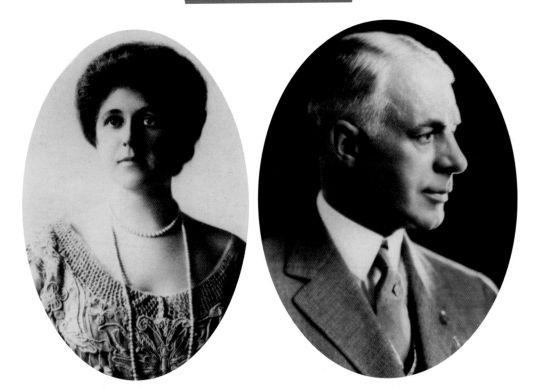

Russell A. Alger Jr. and Marion Alger

Russell A. Alger Jr., the lumber baron, industrialist, and son of Michigan's 20th governor, was one of the founders of the Packard Motor Car Company in 1902. He was an inventor and an early investor in the Wright brothers' airplanes, even bringing them to Grosse Pointe to generate interest in their company. His wife, Marion was a devoted mother who raised their three children in the Moorings, their Italian Renaissance home on Lake St. Clair. An avid gardener, she brought in famed landscape architect Ellen Biddle Shipman to design the home's magnificent formal gardens. The Algers entertained the most prominent names of the day including the Dodges, Fords, and others at the Moorings. The mansion was later given to the community by the family and was dedicated as the Grosse Pointe War Memorial, a veterans memorial and community center that today serves nearly 200,000 visitors every year.

John Lake

John Lake was the beloved first director of the Grosse Pointe War Memorial. A native of St. Louis, he came to Grosse Pointe in 1947 to teach history at Grosse Pointe High School. Five years later, he was asked to be the first director of the war memorial by Alger Shelden, a nephew of Russell Alger Jr. and president of the board. For 30 years, Lake led the center through tremendous growth and expansion.

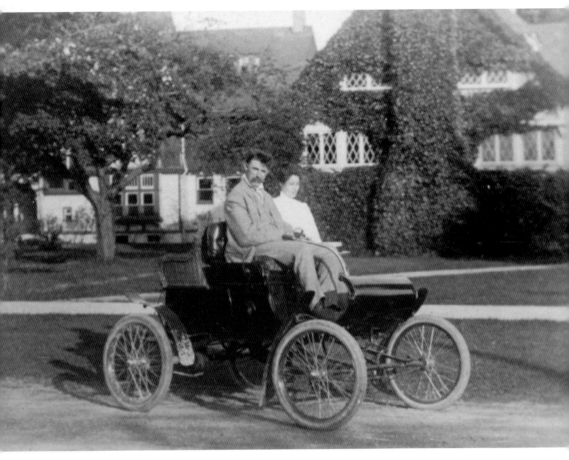

Henry and Charlotte Sherrard
A classical scholar who taught at the respected Detroit Central High School, Henry Sherrard was one of the eminent educators of the Detroit schools. He was the cofounder of Detroit University School (today's University Liggett) in 1899, and he has an elementary school named for him in Detroit. He married Charlotte Berry (they are pictured here), the oldest daughter of prominent businessman Joseph Berry, who was active in civic and charity organizations, including the women's suffrage movement. She was president of the Michigan League of Women Voters.

Roy Chapin

One of Grosse Pointe's great auto barons, Roy Chapin (pictured) was a well-known industrialist who headed up the group of businessmen and engineers that in 1908 founded the Hudson Motor Car Company, one of the most innovative car companies of the era. (The company was named for department store founder J.L. Hudson, who put up most of the money.) Chapin got his start in the automobile business after graduating from the University of Michigan and working as an engineer for Ransom E. Olds's company. In 1901, he famously drove an Oldsmobile from Detroit to New York City in seven-and-a-half days to show the public the possibilities of automobile travel.

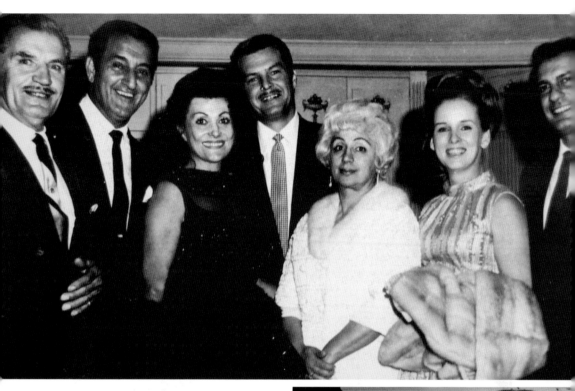

Penny and George Simon

Penny Simon and her husband, George, an internationally successful industrialist and hydroplane-racing legend, raised their 10 children in their lovely Georgian home, which was designed by Robert O. Derrick in the 1920s. Their generosity and graciousness went well beyond their immediate family. They opened their home to friends and to charitable causes they were passionate about. A highlight of their community endeavors had to be hosting the Michigan Republican Party benefit tea honoring Barbara Bush in 1985 when her husband was vice president. The family hosted events for FOCUS: HOPE, and the Grosse Pointe Historical Society, and they continue to be major supporters of St. Jude Children's Research Hospital, founded, with George's help, by family friend Danny Thomas. Penny and George are pictured at the far right in the above image; Penny (left) is pictured with Barbara Bush at right.

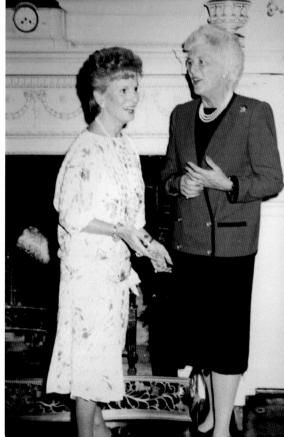

John A. and Marlene L. Boll

For more than 50 years, John A. and Marlene L. Boll have dedicated their lives and feel blessed to be able to help others. They were a moving force in building the Boll Family YMCA in Detroit and the Boll Fitness Center at Grosse Pointe South High School. They recently committed to building a new, state-of-the-art athletics facility at University Liggett School. John is the founder of what is now Chateau Communities, Inc., the largest owner of manufactured home communities in the United States. Marlene trained as a dancer and was a member of New York's famed Radio City Music Hall Rockettes. Both serve on numerous councils, boards, and foundations.

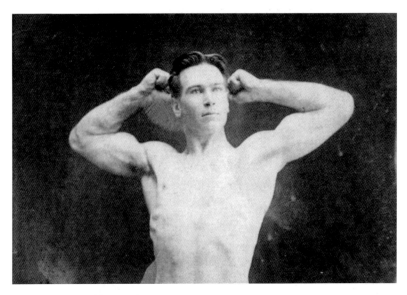

Harry Blondell and the Weaver House

The Weaver House was a two-story frame building located at what is now the northeast corner of Notre Dame Street and Jefferson Avenue in the city of Grosse Pointe. Built in 1875 by Procton Weaver, who had previously operated the Fisher House, it was also known by some as Aunt Kate Weaver's Hotel. It was noted for its frog leg, fish, and chicken dinners and its slot machines and games of chance. Harry Blondell obtained possession of the premises in 1901 and operated there under the name Weaver House until it went dry in 1918. When the building was torn down, Blondell established a dance space installing a player piano to furnish the music. Blondell was one of the most popular resort keepers in Grosse Pointe, and he was known all over the country for his feats of strength, having previously traveled with a circus as a strong man performing on a high platform lifting horses and groups of people with a harness over his shoulders. Blondell gave nightly exhibitions of his strength gratis for the amusement of his many patrons, and the Weaver House was the most patronized place in that vicinity. Guests came from far and near bringing old telephone books and decks of playing cards with them. Blondell would tear the books and card decks into small squares with his bare hands. He would also bend iron bars around his neck while bending dimes and quarters with his fingers before returning them as change to his customers. Many of the patrons came a long way to obtain bent coins from Blondell for souvenirs.

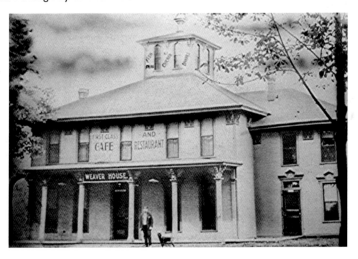

Alice Dwight Berry
The daughter of Joseph Berry, a paint and varnish tycoon, Alice Lodge was very involved in the community. She taught Sunday school and played the organ in the original ivy-covered Grosse Pointe Memorial Church that her father helped found. She was also a member of the Detroit Museum of Art Founders Society, the Detroit Symphony Orchestra, and the Needlework Guild of America. Her husband was Edwin Lodge.

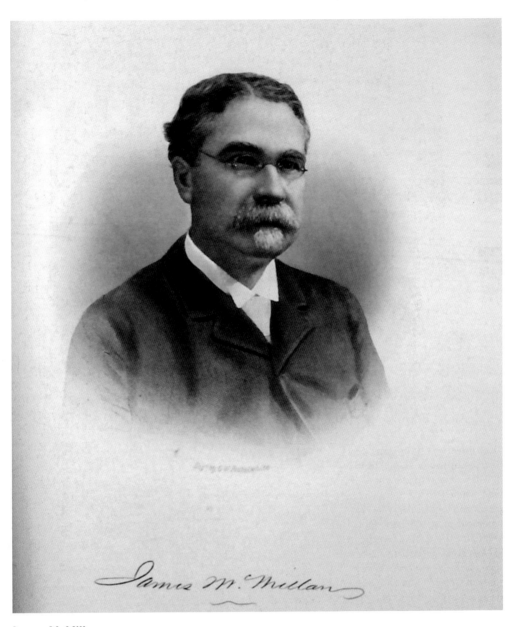

James McMillan

James McMillan, together with his good friend John S. Newberry, had a huge impact on the financial and industrial growth of Detroit in the mid- to late 1800s. Many also credit them with transforming Grosse Pointe from a rural, French-speaking community to an exclusive summer retreat for Detroit's business leaders. He and Newberry met at Jefferson Avenue Presbyterian Church and began a business partnership that included many of Detroit's major companies, including the Michigan Car Company, a railway company, Michigan Telephone, and Edison Electric Company. The two built identical cottages next to each other on Lake Terrace. McMillan led the development of Belle Isle as a public park. He was also a successful politician, elected to the US Senate in 1889. While in Washington, he was elected chairman of the District of Columbia Committee and oversaw many major improvements to the city's layout.

Theodore H. Hinchman

New Jersey native Theodore H. Hinchman came to Detroit in 1836 and became a highly successful grocer and wholesaler. He was a member of the Michigan State Senate for the Second District in 1877. A great outdoorsman, he built a large, clapboard summer home in Grosse Pointe in 1862. He and his family lived there from June to September, entertaining friends and family and enjoying the many amenities of life on the lake. Years later, Russell Alger summered there with his family. They liked the property so much that they bought it, tore down the cottage, and built the Moorings, now the Grosse Pointe War Memorial. Theodore is on the far left in the top image. He is pictured at right as a younger man, having fun on his boat dock.

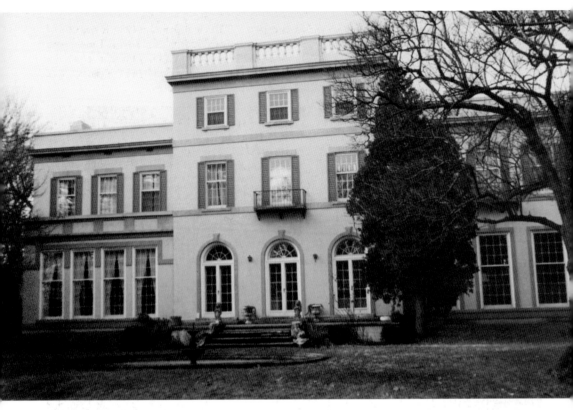

Murray W. Sales
While living in Grosse Pointe at his home, Edgeroad (pictured here), Murray W. Sales lead a successful national campaign to improve health laws protecting consumer canned goods. In 1926, he donated $100,000 to kickoff the campaign and build Cottage Hospital in Grosse Pointe Farms.

Crowley Family

Crowley's was founded by Joseph J. Crowley and his brothers William and Daniel in 1909. It was one of the three popular department stores in downtown Detroit along with Hudson's and Kern's. Those three stores, located near Woodward Avenue and Monroe Street, near today's Campus Martius, created a shopping hub downtown. At one time, Crowley's was the largest department store in Michigan and was known for its high-quality goods. Pictured is Mrs. Crowley with her two children.

Truman Newberry

Truman H. Newberry had a successful career in business as well as the US Navy. He was an early investor in the Packard Motor Company and was president of the Detroit Steel and Spring Company, among other business interests. He was a lieutenant commander in the US Navy during World War I and later served as assistant secretary of the Navy. He also served as a US senator. He and his wife, Harriet (both pictured at left), presided over their beautiful estate, Drybrook. Truman and his brother John Jr. donated more than $287,000 for the sanctuary of the present Grosse Pointe Memorial Church, so named because it was to be a memorial to their parents, John and Helen Handy Newberry. Truman and Harriet are pictured seated in the center in the bottom image, surrounded by family members.

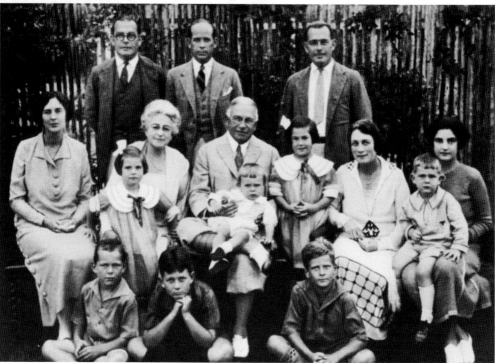

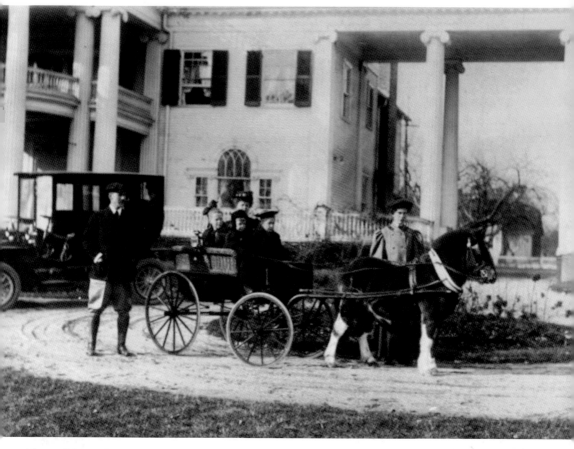

Mayor Alexander Lewis

Detroit's 36th mayor, in 1875, Alexander Lewis owned a farm in Grosse Pointe where this house, his summer residence, was built. His son lived in a twin house next door; they were adjoined by a connected, two-story porch. That house was torn down. The other is now the Parish House for St. Paul Catholic Church. Lewis ran on the Law and Order ticket that favored closing saloons on the Sabbath and providing a proper observance of the Sabbath. He raised 13 children in Grosse Pointe. Lewiston Road is named after him.

Allard Family

The Allard family had several farms in Grosse Pointe dating back to Jacques Allard's 102-acre farm established in 1808. Louis Allard and his wife, Theresa, are buried in St. Paul's Cemetery at Ridge and Moross Roads. Their great-granddaughter Sister Clement of the Sacred Heart Convent recalled the men of her childhood hauling the large stones to make up the foundation of St. Paul's Church. Edward Allard, pictured here, was a private in the US Army during World War I.

Charles and Kate Backman Charles and Kate Backman ran the Backman Grocery Store (pictured at left) around 1894; it sold everything from produce, to penny candy, to children's shoes. The Backman store delivered in those days and the horse and wagon were housed in an old barn behind the building. Behind the store were the living quarters where the Backman family resided, pictured below.

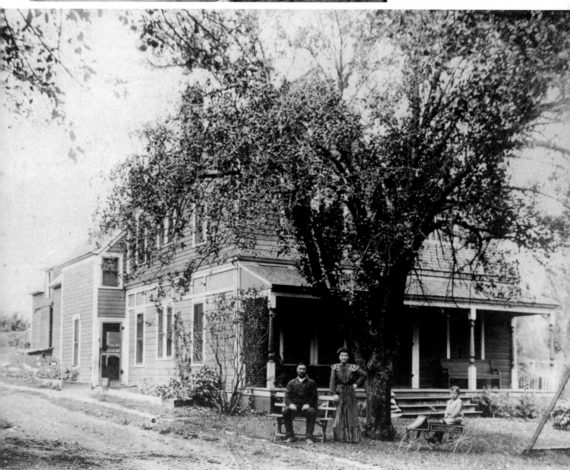

Dr. David and Shery Cotton
Dr. David Cotton, former specialist-in-chief of obstetrics and gynecology at Detroit Medical Center and chair of the Department of Obstetrics and Gynecology at the Wayne State University Medical School, founded Health Plan of Michigan, Inc., now Meridian Health Plan, in 1997. It is now the state's largest Medicaid HMO. Dedicated philanthropists, the Cottons (pictured below) funded the creation of the Cotton Family Medical Library in the medical office building of St. John Providence Park Hospital in Novi and the Shery L. and David B. Cotton, M.D., Family Birth Center at Beaumont Hospital in Grosse Pointe. They are also credited with bringing a number of businesses to the Grosse Pointe Park business district on Kercheval Avenue.

Elizabeth Whitehead Pierson

James T. Whitehead was the president of Whitehead and Kales, a manufacturer of structural steel for buildings and bridges. His daughter Elizabeth was afflicted with polio so he brought her to Warm Springs, Georgia, where Pres. Franklin Delano Roosevelt went regularly to for treatment to swim in the warm, mineral-rich waters of this Georgia resort. Whitehead had purchased Hart Cottage from FDR and became one of the founding trustees of the Georgia Warm Springs Foundation. Elizabeth was present at many of the parties, picnics, and special events held when FDR was in Warm Springs. She and Mary Veeder recorded many of these events on camera. Because of her closeness to FDR in the early days, her scrapbook and movies are priceless records of life at Warm Springs. Eleanor Clay Ford was her childhood friend and Elizabeth was responsible for bringing Eleanor and Edsel Ford to visit Warm Springs. They made a $25,000 donation to enclose the pools. Elizabeth's father died in 1930 and left Hart Cottage to her. She gave the cottage to the Georgia Warm Springs Foundation in 1951. Elizabeth married H. Lynn Pierson, president-treasurer of the Detroit Harvester Company. Henry Toombs designed a house for them in Grosse Pointe where they raised two children, Nancy Pierson Gard and Davison Pierson.

Three Community Leaders
Three leaders of civic and philanthropic efforts in Grosse Pointe and metro Detroit kibitz at a local fundraiser. Grosse Pointe Park mayor Palmer Heenan (left) hasn't lost his passion for people or politics at age 89. John Danaher (center), vice president for development of the Beaumont Foundation, has raised millions for Beaumont Hospital and was a key figure in the new Neighborhood Club partnership. Detroit Historical Society executive director and chief executive officer Bob Bury (right) recently oversaw the major revamping of the Detroit Historical Museum and the Dossin Great Lakes Museum.

Lisa Mower Gandelot
Community activist Lisa Mower Gandelot, pictured with her husband, Jon, was a key figure in the expansion and enhancement of the Grosse Pointe Historical Society. She joined the board in 1982 and also served as its president for a number of years. Under her leadership, the GPHS found a permanent home, added a log cabin, and made major renovations to the buildings. She also helped create a program to register local historical buildings with the state of Michigan's historical marker campaign. She taught school and worked as the development director for the Children's Home of Detroit for many years.

Robert B. Edgar

In the early 1940s, with the financial backing of Theodore Buhl, second-generation newspaperman Robert B. Edgar opened the *Grosse Pointe News* in a few crowded offices near the old Punch and Judy Theatre on Kercheval Avenue in Grosse Pointe Farms. Edgar got his start at the *Scranton Sun* in the late 1920s where his father, Mark, was editor. He ran the *Grosse Pointe News* until his death in 1979 when his son R.G. "Butch" took over for nearly three decades.

Robert Liggett

Robert Liggett rescued Michigan's beloved Big Boy restaurants from Chapter 11 bankruptcy by purchasing the assets from the Elias Brothers Corporation in December 2000. Liggett's first business love was broadcasting, beginning as a teenage disc jockey in Mount Clemens. In 1970, he bought his first radio station, WFMK in Lansing, and he went on to establish the Liggett Broadcast Group, which, at its peak, held more than 25 stations across the country. He sold the company in 2000, and currently owns the *Grosse Pointe News*.

John Bruce
John Bruce led the Neighborhood Club for 40 years. During that time, the center experienced tremendous growth. A former Pierce Middle School English teacher, Bruce started in 1971 and, by 1975, the club's activities and membership had more than doubled. Through the decades, programs and activities continued to expand. An annual fund campaign was established and began to raise significant resources for the center. New programs were created and today the club organizes more than 600 teams with 7,500 players and schedules more than 3,000 games, classes, and clinics each year. Bruce paved the way for the new, $10-million facility, which opened in January 2013.

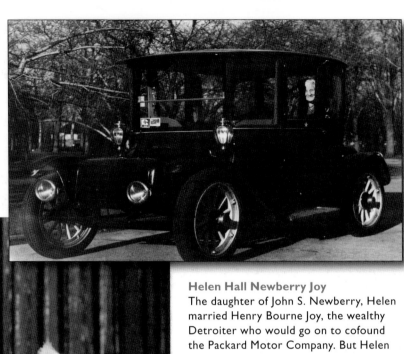

Helen Hall Newberry Joy

The daughter of John S. Newberry, Helen married Henry Bourne Joy, the wealthy Detroiter who would go on to cofound the Packard Motor Company. But Helen was quite accomplished on her own. Small in stature but with a big personality and convictions, she was a tireless supporter of many civic organizations and donated money for a residence hall at the University of Michigan and a hospital in the Upper Peninsula. She could be seen driving her 1914 electric automobile around the Pointes, even into her 80s.

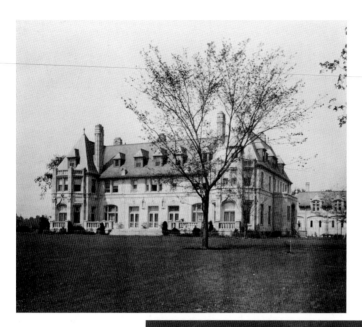

Book Brothers
The Book-Cadillac Hotel, synonymous with luxury and elegance in its day, was the brainchild of the three Book brothers—J. Burgess, Frank, and Herbert. They commissioned Louis Kamper to design the $14-million building in 1923. It had 1,136 guest rooms, three dining rooms, three ballrooms, and a ground floor retail arcade. On the hotel's top floor was radio station WCX, the predecessor to WJR. Herbert Book lived in this mansion in Grosse Pointe Farms.

John LaBelle
John LaBelle, pictured here with his family, was a grocer who bought the Provencal-Weir House for $400 in 1912 when it was still on Lake St. Clair. Thinking it was too cold and windy for his family to live there, he had it moved to its present location at 376 Kercheval Avenue. He also added a new kitchen and dining room. It is the oldest house in Grosse Pointe and is now the headquarters of the Grosse Pointe Historical Society.

Frank W. Hubbard
Frank W. Hubbard was vice president of the Banker's Trust Company of Detroit, one of nine new trust companies to open between 1914 and 1929 in response to the city's tremendous economic growth. At that time, he had founded or presided over 11 other banks in Michigan. He founded Hubbard Memorial Hospital in Bad Axe, Michigan, in 1903 as a tribute to his father.

FRANK W. HUBBARD
BAD AXE
PRESIDENT FRANK W. HUBBARD & CO., BANKERS

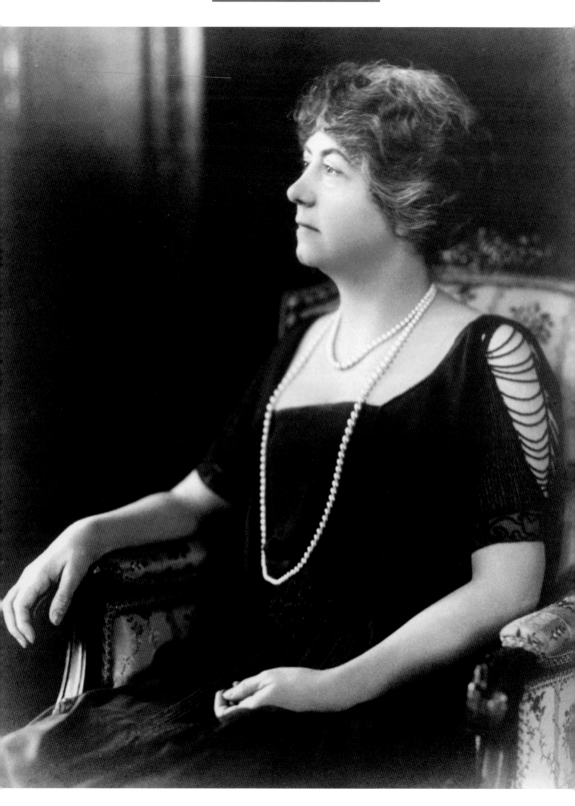

Anna Thompson Dodge (OPPOSITE PAGE)
When Anna Thompson Dodge died in 1970, reportedly just shy of her 99th birthday, she was one of the richest women in the world. The widow of ingenious inventor and auto baron Horace Dodge, she left an estate worth more than $80 million, including the 42,000-square-foot mansion, Rose Terrace II. She and Horace both had much humbler origins. Anna was born in Scotland, came to Detroit with her mother, and supported herself and her mother by giving piano lessons. Horace was an auto mechanic when they met, but he went on to become one of the most successful automotive pioneers in the industry. Their two children, Horace Jr. and Delphine, led lives one might expect of children raised amid so much excess and privilege: marrying often, partying much, and dying young. Six years after Horace Sr.'s untimely death at the age of 52, Anna married actor and playboy Hugh Dillman, who was reportedly 14 years her junior. That marriage ended in divorce, but not before the couple tore down the first Rose Terrace and built a second, more lavish mansion, designed after one in Newport, Rhode Island. Anna died there and the home stood empty until it was torn down in 1976.

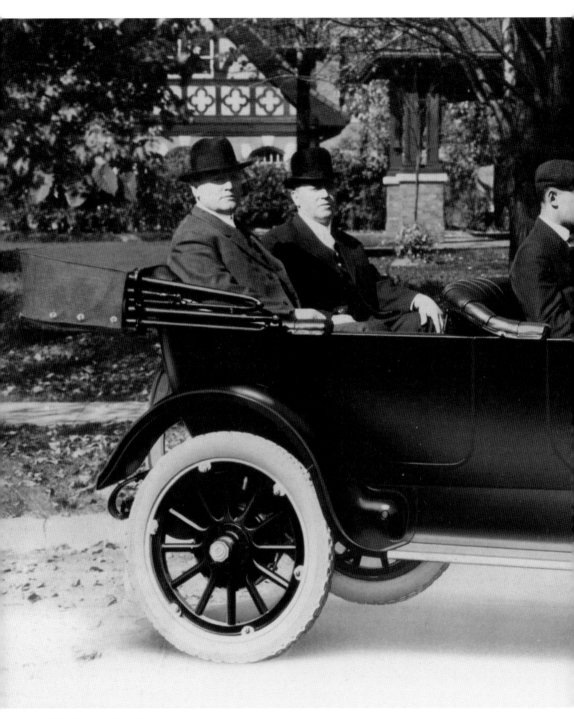

The Dodge Brothers
Born into a poor but hardworking family in the small, western Michigan town of Niles, John and Horace Dodge resolved to use their talents and determination to reach the pinnacle of industry success. Best friends and business partners, they started off building engines for Ransom E. Olds and Henry Ford.

They realized they could make much more money with their own automobile company and established the Dodge Brothers Motor Car Company in 1910 in the iconic "Dodge Main" plant, designed by Albert Kahn. In January 1920, John (back seat, left) was stricken with pneumonia and died at the age of 56. Horace (back seat, right) was devastated by the loss and died in December the same year.

109

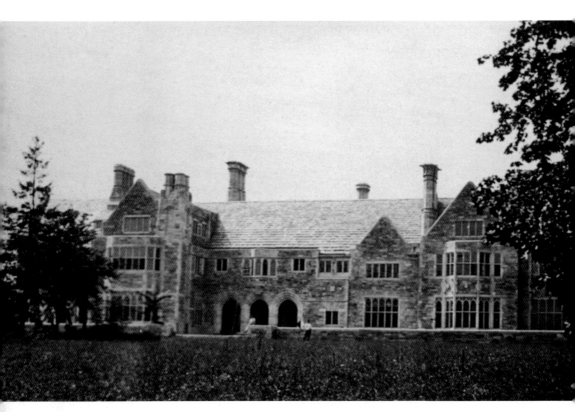

John Dodge

Before his death, John Dodge was in the process of constructing a $4-million, 80,000-square-foot house on Lake St. Clair. It included a man-made peninsula to accommodate his brother's yachts during visits. His home would have been the largest in the state of Michigan, but it was never completed. After disputes with her stepchildren over John's estate and being snubbed by Grosse Pointe society, John's widow, Matilda, abandoned his dream. She built the $4-million Meadowbrook Hall in Rochester using many features—including stonework, windows, and more—that were removed from the unfinished mansion.

Harry Jewett

A football standout who played halfback for Notre Dame, Harry Jewett of Elmira, New York, was reportedly the first Fighting Irish player to score a touchdown against the University of Michigan in 1888. He also played baseball and ran track for Notre Dame. A civil engineer, Jewett (pictured above) was hired as president of the newly formed Paige-Detroit Motor Car Company in 1909. From 1923 to 1926, the company built the Jewett car. It had a big, in-line, six-cylinder engine that made it popular out west where it was able to climb mountains. Fewer than 40,000 were built during Jewett Motor Company's four years of production.

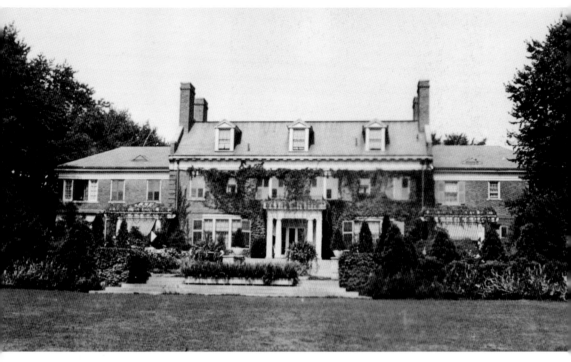

B.E. Taylor
B.E. Taylor was a prominent Detroit real estate developer. He created the Brightmoor neighborhood on the city's far west side as a planned community of inexpensive housing in the early 1920s. Taylor recruited workers from Appalachia to live there with promises of jobs in the expanding auto industry and the chance to own their own homes. He lived in this house on Lake Shore Road in Grosse Pointe Shores, to which he added dramatic landscaping including a pavilion with a teahouse and dressing rooms for the swimming pool. Henry Ford II lived here after Taylor.

The Fords

Siblings Emory Ford, Stella Ford Scholtman, Hetty Ford Speck, and Nell Ford Torrey—the grandchildren of Michigan Alkali Company founder Capt. John B. Ford—all built their mansions near one another along Lake Shore Road. The home of prominent surgeon Dr. Harry Torrey and his wife, Nell, was an elegant Beaux-Arts mansion named Clairview. The home was built on the former Clairview stock farm property. Their children, William and Eleanor (pictured top and bottom), spent many delightful hours playing on the grounds of the estate. The Torreys later donated two acres of their property to build the Grosse Pointe Woods Presbyterian Church on today's Mack Avenue.

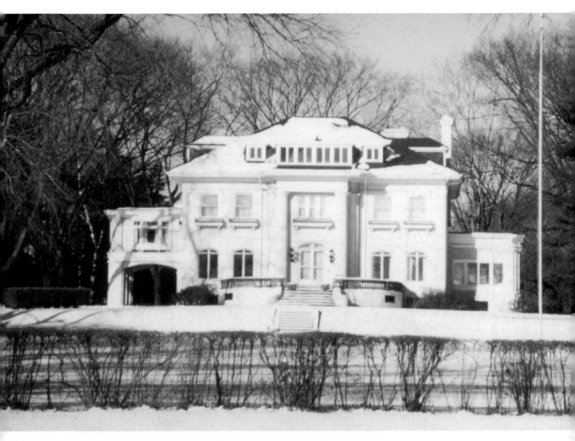

Benjamin S. Warren and the Wanikan Club
Successful attorney and businessman Benjamin S. Warren, whose home is shown here, helped found the golf course that was the predecessor to the Country Club of Detroit. Together with Howie Muir, Cameron Currie, and the McMillan sons, they developed a nine-hole course that ran along Fox Creek at Alter Road from Jefferson Avenue toward Lake St. Clair. They named it Wanikan, an Indian phrase meaning "hole-in-the-ground."

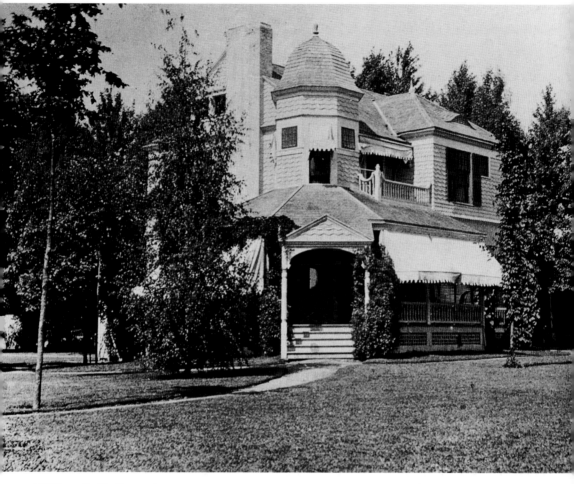

William A. McGraw

William A. McGraw was known as one of the oldest and most successful mercantile firms in Detroit. He was a leading and most influential businessman of his time. His name became synonymous with integrity, reliability, and progressiveness. He married Harriet A. Robinson, a niece of John S. Newberry, and they had a pretty little Queen Anne cottage known as the Poplars in Grosse Pointe for 35 years. A handsome row of Lombardy poplar trees defined the front yard. Also in front of the house was a little park, shared with neighbor John Dyar, that extended to the lake. The entrance of this house was redesigned for Percival Dodge in 1927 by Robert O. Derrick.

Bill McCourt

Generations of children made the annual trek to Bill McCourt's store for back-to-school shoes and Docksiders. He started his business in Grosse Pointe in 1949. By 1972, he had become so successful, he built the McCourt Building on Kercheval Avenue and Notre Dame Street, which housed McCourt Shoes until 1984. After retiring, Bill and his wife, Laura, sold their home, bought a 47-foot ketch, and spent the next 20 years sailing around the world.

John B. Ford Jr.

John B. Ford Jr. was the son of the founder of the Wyandotte Chemical Corporation (now BASF Wyandotte). He was vice president of that company and a founding member of the National Bank of Detroit. He was also a philanthropic leader responsible for revitalizing the Detroit Symphony Orchestra in the early 1950s. This house was redesigned for his family by Robert O. Derrick in 1927.

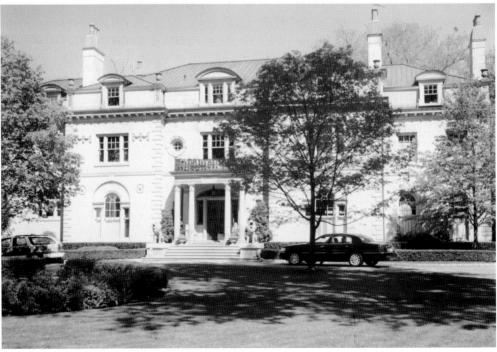

Samuel Brownell

When Samuel M. Brownell took the job as superintendent of Grosse Pointe schools in 1927, he inherited a district that had been formed by bringing together five rural school districts with an enrollment of 2,115 students. When he left 11 years later, enrollment had almost doubled and the district was lauded nationally as one of the finest in the country. The son and grandson of teachers, Brownell taught high school in his native Nebraska before coming to Grosse Pointe. Under his tenure here, the district built a high school, three new elementary schools, additions to two existing elementary schools, and plans were made for a junior high school, later named for him (Brownell Middle School). Just as important as the buildings were the improvements made to the quality of education. Among other things, he increased the educational requirements of teachers and established a guidance program for students. Brownell left Grosse Pointe in 1938 to become the professor of educational administration at Yale University and later became president of the New Haven State Teachers College and the US commissioner of education under Pres. Dwight Eisenhower. He returned to Michigan to become Detroit's superintendent of schools in 1956–1966 and brought significant, progressive improvements to a system that was in disarray. He received the Equal Opportunity Day Award from the Detroit Urban League. He returned to teach at Yale and died in New Haven in 1990.

Paul Deming

Paul Deming came to Detroit to become vice president of the American State Bank in 1905. He built a large home on the lake where he and his wife, Helen, raised their family. Called Cherryhurst, it was one of the first permanent residences in Grosse Pointe Farms. Deming became very involved in village business and served as president of the village. He was a past president of the Country Club of Detroit, an organizer of the Grosse Pointe Hunt Club and the Little Club, a member of the League of Lower Lakes Golf, and president of the St. Clair Shooting and Fishing Club for 20 years. Despite being placed on national and state historic registries, Cherryhurst, a Tudor revival that stood on two acres, was torn down in 1997 to make way for the Cherryhurst subdivision on Cherryhurst Lane.

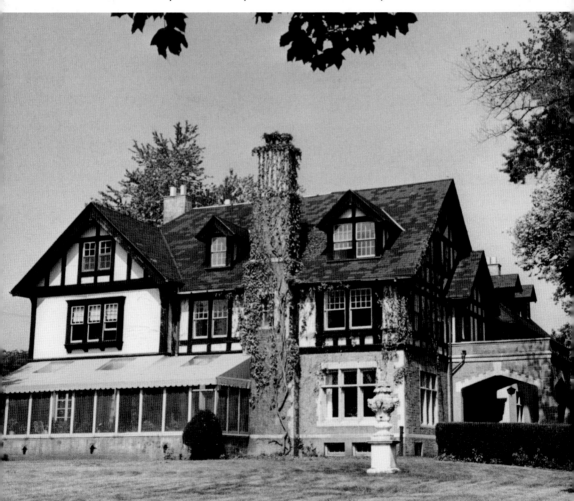

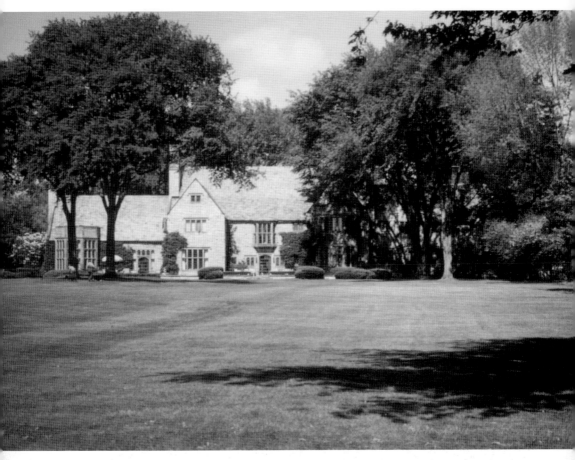

Alvan Macauley

The iconic head of the Packard Motor Company, Alvan Macauley was on the cover of *Time* magazine twice, in 1929 and 1935. He ran the company when it was a leader in the luxury car market. When the Depression hit, he developed a line of lower-priced cars that saved the company. He was elected by his peers (including Ford, Chrysler, Nash, and the Dodge brothers) as president of the Automobile Manufacturers Association for 18 years. He was also head of the Automotive Council for War Production during World War II. He commissioned Albert Kahn to design this Costwold-style mansion on Lake Shore.

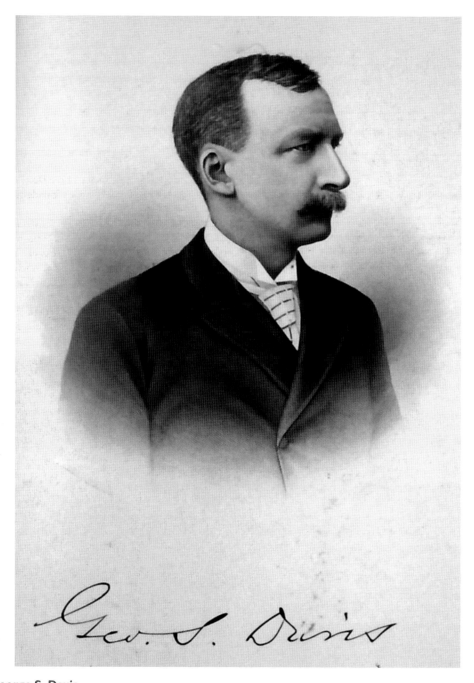

George S. Davis

A partner in the pharmaceutical company Parke, Davis & Company, George S. Davis owned a summer home on 281 acres that he called the Claireview Jersey Stock Farm. This property ran from the lake back to Mack Avenue and included property later owned by the Sheldens, Torreys, and Specks. The farm had 28 buildings, a blacksmith shop, 60 horses, 30 brood mares boarding there, and a herd of Jersey cows, all tended to by 25 employees. On the eastern part of this lot was an orchard, including two large French pear trees.

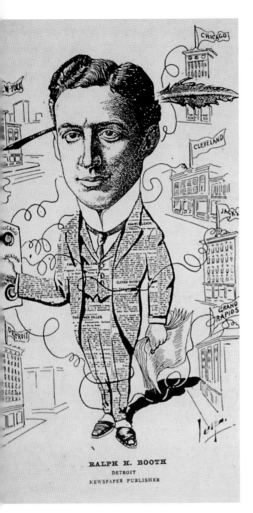

RALPH H. BOOTH
DETROIT
NEWSPAPER PUBLISHER

Ralph Harmon Booth

Ralph Harmon Booth was a publisher of the *Detroit News* and the brother of the newspaper's founder, George. Booth was also one of the great art benefactors of Detroit and was largely responsible for the construction of the Detroit Institute of Arts in the 1920s. His home, designed by Marcus Burroughs, was the largest house in the city of Grosse Pointe when it was built in 1924. Following in the tradition of art collectors like Frick, Whitney, and Widener, Booth filled his home with art and furnishings of artistic and historic significance. Booth also served as US minister to Denmark.

E.J. Hickey
E.J. Hickey Company was a retail legend that sold upscale menswear to generations of Grosse Pointers. His store was originally founded by a J.L. Hudson store manager in 1900 and was located on Woodward Avenue in downtown Detroit. It had several locations in Grosse Pointe and merged with women's clothier Walton Pierce in 1991. In 2009, Hickey's Walton Pierce closed its doors. E.J. Hickey Jr. is pictured at left.

Tony Fadell

Lots of Grosse Pointers couldn't live without their iPods or iPhones—but how many know that a Grosse Pointer led the team that invented them? Tony Fadell graduated from Grosse Pointe South High School in 1991, then earned a bachelor of science degree in computer engineering from the University of Michigan. He became the senior vice president of the iPod Division at Apple, Inc., in 2006 and later was an advisor to Steve Jobs. In 2010, he founded Nest, which created the Learning Thermostat, a device that programs itself, is remote controlled through Wi-Fi, and helps save energy.

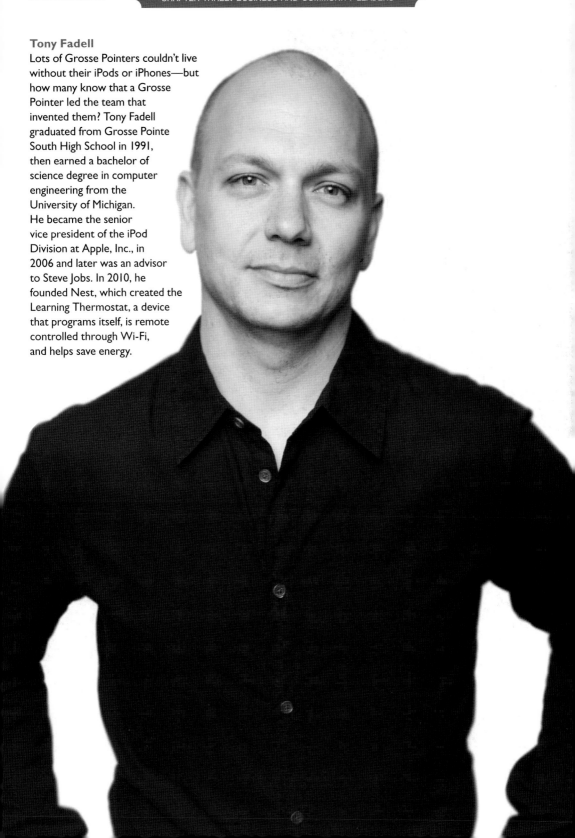

Dr. Mark Weber
Dr. Mark R. Weber recently retired as president of the Grosse Pointe War Memorial after more than three decades at the helm. Under Weber's direction, the community center saw an expansion of programming and projects and today has about 200,000 visitors a year and hosts 5,000 events, continuing its mission as an educational and cultural resource for the community in honor of veterans. A native Grosse Pointer, he came to the war memorial from Indiana University, where he received his doctorate in adult continuing education and ran the conference center for the School of Continuing Studies.

Diane Strickler

Community activist Diane Strickler founded the Family Center of Grosse Pointe and Harper Woods in 2000 and was executive director through 2007. The mission of the center remains to promote a deeper understanding of the role of parents and others in supporting youth to become competent, capable, and responsible community members. She is still very involved in the community as president of the Rotary Club of Grosse Pointe and has been honored with the Grosse Pointe Chamber of Commerce Pointer of Distinction Award, the Grosse Pointe Rotary's Frank Sladen Visionary Award, and other community service awards. .

Mary Fodell

Mary Fodell (center) taught art in the Grosse Pointe Public Schools for 33 years, retiring in 2006. The mother of a daughter with special needs, she is acutely aware of the needs of the community, which gave her the idea to found the Full Circle Foundation. The group works in conjunction with the Grosse Pointe Public School System to provide opportunities for increased independence for special needs individuals within our community. Integral parts of the program are the Upscale Resale Shop, which provides training in the operation of a retail shop, and the Full Circle Urban Garden, an organic garden created for the purpose of teaching young adults to plant, grow, maintain, and harvest organic produce.

INDEX

Find more books like this at
www.legendarylocals.com

Discover more local and regional history books at
www.arcadiapublishing.com